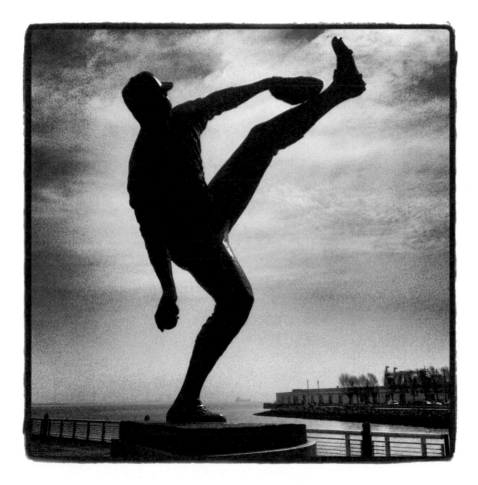

Photographs by Brad Mangin

Instant Baseball

Foreword by *Pedro Gomez*
Book design by *Iain R. Morris*

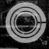 Cameron + Company

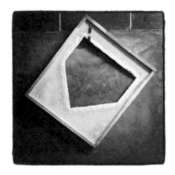

Instant Baseball
Text & Photographs © 2013
Brad Mangin

Foreword © 2013 Pedro Gomez

Library of Congress Control Number: 2012954801

ISBN: 978-1-937359-41-6

Printed and bound in China

10 9 8 7 6 5 4 3 2 1

Follow Brad Mangin on Instagram @bmangin

Cameron + Company

6 Petaluma Blvd. North
Suite B6
Petaluma, CA 94952

707 769-1617
www.cameronbooks.com

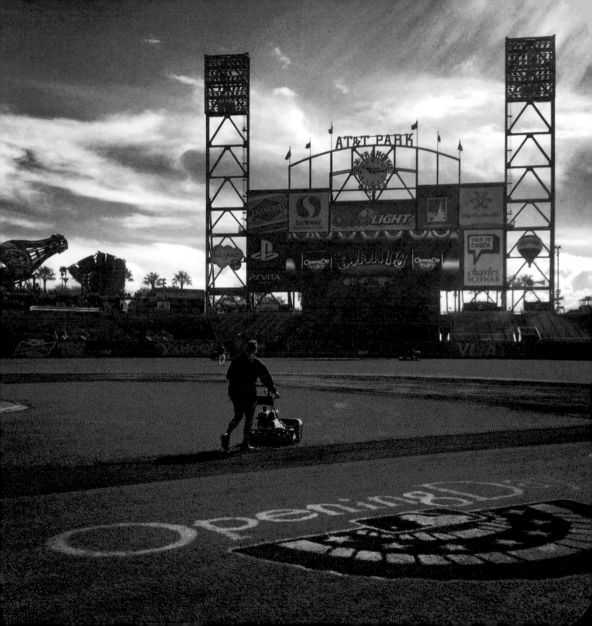

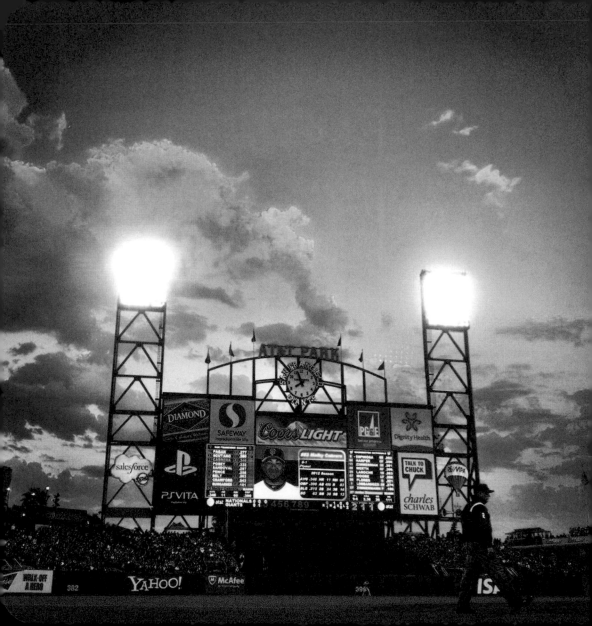

Contents

Foreword

It seems like every year since I started covering baseball full time in 1992, a vocal minority has been insisting that baseball is a dying sport. They were wrong then and they're wrong now. The simple fact is baseball remains entrenched inside the heart of the American sports fan in ways that other sports can only dream about. Want proof? When an NFL player is busted for using performance-enhancing drugs, it barely registers on the consciousness of American sports fans. But when it's a baseball player, all hell breaks loose. It becomes the lead story for every news outlet. Think about it. Why the difference? *Because among sports baseball represents this country best.* It is not merely entertainment. We care as a country about baseball remaining pure. We care about it being a sport we embrace for more than just one day a week.

Part of it is the rules. You cannot have a five-run lead in the eighth inning and simply take a knee and run out the clock. Baseball requires that all 27 outs be recorded. There is no clock telling the players to stall or, as in the not-so-long-ago days, implement a four-corner offense on the court.

This fundamental difference that sets baseball apart was once again demonstrated during the 2012 postseason, when the Washington Nationals were a mere few outs away from putting away the St. Louis Cardinals in the National League Division Series. But, just as they demonstrated during the 2011 World Series—when the Cardinals were twice within one strike of having their season end—St. Louis rallied in dramatic fashion to win the series.

This is a sport that actually allows you to digest what is happening in real time without watching twelve slow-motion replays. You see and sense a rally unfolding. Runners reach base. That tying or go-ahead run is suddenly in the batter's box or on-deck circle. You don't dare turn away because you can actually process what is transpiring. For those who call baseball too slow, it's possibly that they simply do not have an appreciation for absorbing the mental chess game that takes place, especially when the stakes are raised in September or the always heightened month of October. The late fall is when the pressure mounts to almost unbearable proportions.

Baseball dying? Hardly. And the San Francisco

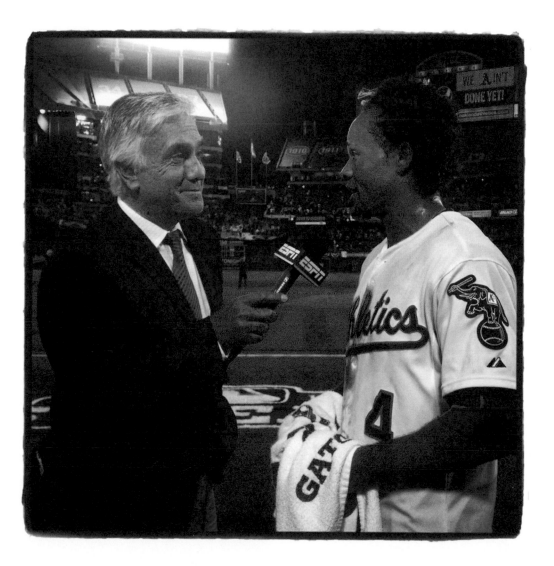

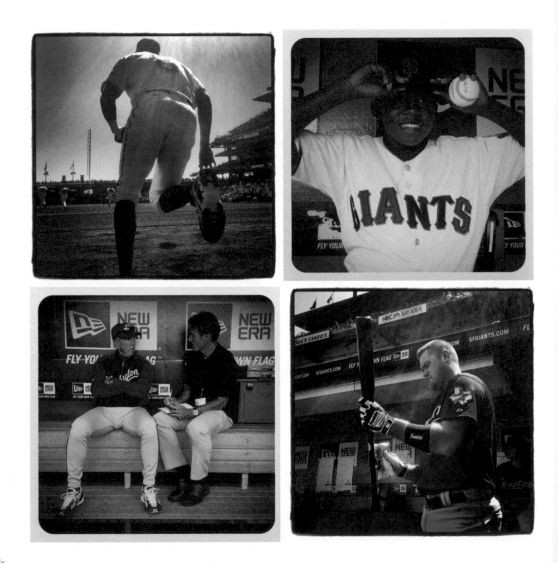

Bay Area may be the epicenter of the game's renaissance. During 2012, the Giants' fan base once again displayed just how zany and devoted they are. Even with closer Brian Wilson reduced to little more than a bearded cheerleader, the Giants embodied what happened across the game last season by never giving up hope, even when they lost their first two playoff games at home to Cincinnati before rebounding to win the last three games and advance to the NLCS.

The Texas Rangers came to Oakland for the final three games of the regular season, needing only one win to secure the American League West title. The A's, and their hard-core fan base, made matters nearly impossible for the Rangers, who lost all three games and wound up playing in the new wild card game, losing to the Orioles in the one-and-done format. It was truly a costly three games in Oakland, which then lost its first two playoff games in Detroit before storming back to tie the best-of-five series with a pair of incredible victories in front of what were considered the loudest and most active home crowds during the 2012 playoffs.

Even with the price of going to a game higher than ever, baseball remains a game in which fans feel like they bond with the players more than in any other sport. The biggest reason is because baseball players look just like the rest of us, yet can perform so much captivating magic on the diamond.

It may be true that baseball now feels like the underdog of sports, trailing in television ratings behind the NFL and NBA. But the reality is that this may be exactly where baseball needs to be, since it is a sport filled with so much substance. The comeback stories from 2012 underscored just how much baseball has a grip on the sports fan's psyche. Giants catcher Buster Posey had his ankle practically shredded in midseason in 2011; there was talk that he would never be the same, especially behind the plate. Instead, Posey caught far more games than even the Giants believed he was capable of. And in the end, Posey not only won his second World Series ring in three years, he wound up being named the league's Most Valuable Player.

And the NL's best pitcher was the Mets' R. A. Dickey, the knuckleballer who before the 2012 season was probably best known for writing a book, *Wherever I Wind Up*, about his early-life difficulties and overruling the Mets' front office objections to his climbing Mount Kilimanjaro. All he wound up doing was winning the Cy Young Award at age 38 and gaining fans by the thousands each time he pitched or spoke so eloquently and passionately from the heart.

In these pages, photographer extraordinaire Brad Mangin captures the sights of the 2012 season, one of the most exciting in recent memory. The sounds may be missing, but if you look close enough at the pictures, you can almost hear the unmistakable reverberations that emanate from major league stadiums. They're unlike anything that can be heard in any other sports venue.

—Pedro Gomez

Introduction

The grass at Scottsdale Stadium was bright and emerald green. The infield dirt was a lush combination of red and brown, as if bricks had been crushed and spread about the desert floor. It was the first game of spring training, and my first assignment of the Cactus League season. The game would not start for an hour and

there were so many photo opportunities in front of me. I immediately grabbed my camera and started shooting the grounds crew chalking the area around home plate. I shot some details in the dugout. Did I use my Canon digital SLR? No. Was I shooting with my Canon point-and-shoot camera? Nope. I was shooting with my new favorite camera: my Apple iPhone 4s.

I finally joined the rest of the civilized world and got an iPhone last year and immediately started goofing around with its camera. I soon realized that I could make some really nice pictures with this phone. I could also make some really bad ones. With not many hours of daylight over the winter and no ballgames to shoot, I practiced my iPhone camera skills by shooting pictures of my cats, Mike and Willie. Some of the pictures were kind of cool, but most of them sucked. I needed help.

I was starting to have more fun with my new camera, but the app that really sent me over the edge into becoming a maniac about it was Instagram. I knew about Instagram before I got my phone. I had seen wonderful images shot by other photographers and learned about the fun social

networking features it had, but it did not make much sense to me until I downloaded the free app and started messing around.

Once I began getting the hang of Instagram and continued to flood my feed with pictures of Mike and Willie I had my eureka moment. "How fun would it be to shoot Instagrams with my iPhone during baseball season, when I spend all my time at the ballpark?" I asked myself. I was determined to challenge myself to come up with fun and creative images surrounding the game of baseball to share with everyone on my Instagram feed, Facebook, and Twitter. Spring training would be my first big test.

I was never one of those photographers who cruised around while off duty carrying a camera to shoot anything and everything that happened around them. When I was just out of college in the late 1980s, all the cool kids walked around with a Leica slung over their shoulder, loaded with black and white film. I was never rich enough or cool enough to have one, so I opted for nothing. I hate carrying camera gear. Heck, I have not worn a watch in over twenty years, and I hate the feel of keys in my pocket. I like to travel light. But I always have my cell phone with me. Now my cell phone is a camera! I can finally look at the world with a fresh eye—at age forty-seven.

I spent a few weeks in Arizona shooting spring training games on assignment for *Sports Illustrated* and tried to look for interesting things to shoot every day with my new camera. Since I had to

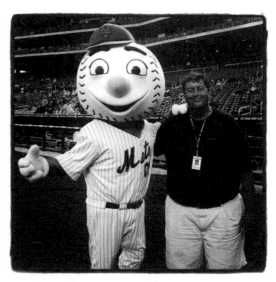

photograph the games professionally and be on the lookout for certain players, I did not have free rein to wander around the park just looking for square pictures for my Instagram feed. However, before the games I always had a little bit of time to scout around and see what looked good. Some of the pictures turned out better than others, but the important thing is I was having fun—and I was being a photographer.

By the time the regular season opened in April, I felt like I was shooting baseball for the first time ever, through the lens of my iPhone and the square format of Instagram. I started looking at everything with a fresh set of eyes from the moment I walked

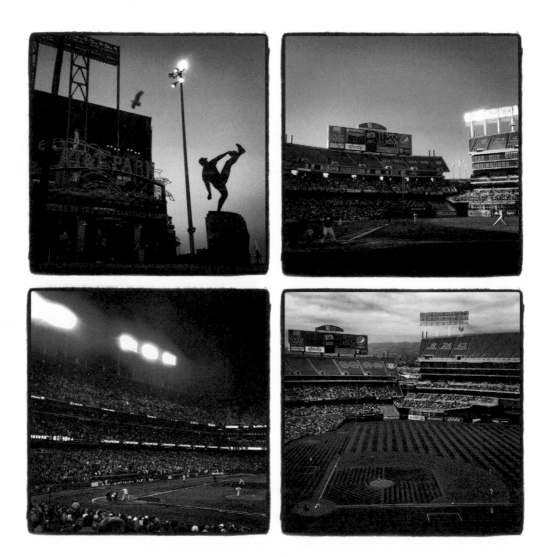

onto the fields in Oakland and San Francisco about three hours before each game. It was like I was a newborn shooter, seeing things for the first time.

I was naturally drawn to the dugouts, where I found many baseball-related pieces of equipment that made for good pictures. By the time the players came and sat in the dugouts before the games, I was ready to try to capture them getting ready. I felt pretty strange not using my Canon DSLR, just shooting with my iPhone. I eventually became more comfortable and started getting some pictures of the ballplayers that I liked.

Early in the season, I talked to Nate Gordon, my baseball picture editor at *Sports Illustrated*, about trying to put together a photo essay with these pictures. He thought it was a good idea and continually coached me on different things to look for. Once I had enough variety he told me he would pitch the story to the editors. Thanks to all of Nate's hard work, the magazine published eighteen of my baseball Instagrams over six pages of the "Leading Off" section in the front of the magazine's July 23, 2012 issue. I was hooked, and I couldn't stop.

There were still several months to go in the season and I realized that I had a nice project going on that needed to be finished. This meant continuing to shoot Instagrams with my iPhone through the end of the World Series.

Working in a region like the Bay Area means that I get to shoot every team as they come through to play against the A's and Giants. I tried my best to shoot players on every team so my collecting of Instagrams from the season would tell the story of the entire season, not just the home teams.

I had already photographed Angels star and American League Rookie of the Year Mike Trout in Oakland early in the season, so I needed to get his National League counterpart, Bryce Harper of the Nationals. I needed him to pose for me, and when he came to San Francisco in August I showed him a copy of the magazine with my Instagrams, and asked if he would pose for me after batting practice. He was so into it he said he wanted to do it in his game uniform. I waited for him to come back out twenty minutes before the game and got him to sit for three frames with my iPhone. After this I did not care what I shot during the game. I had gotten what I needed!

September and October proved to be very busy for me as my iPhone took me to New York to shoot Instagrams at Mets and Yankees games. I also shot playoff and World Series games in Oakland, San Francisco, and Detroit.

After the Giants won the World Series I wrapped up my season-long project by shooting their parade in San Francisco. This collection of pictures from the beginning of spring training in February through the parade on Halloween is what you hold in your hands. I call it "Instant Baseball." I hope you enjoy it.

—*Brad Mangin*

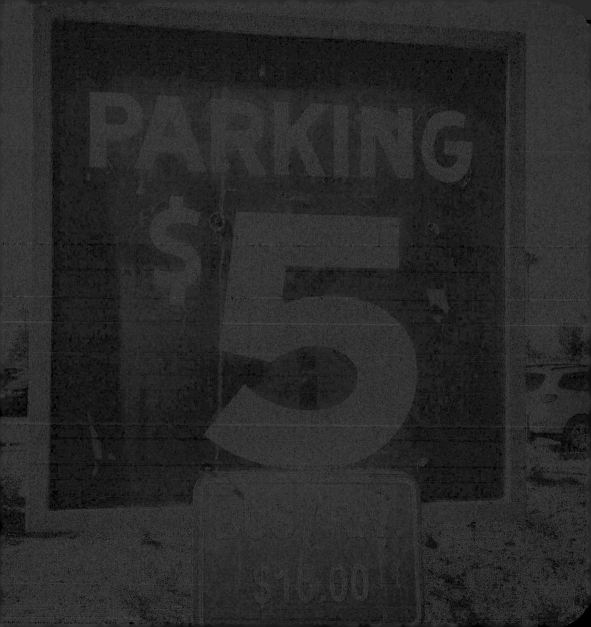

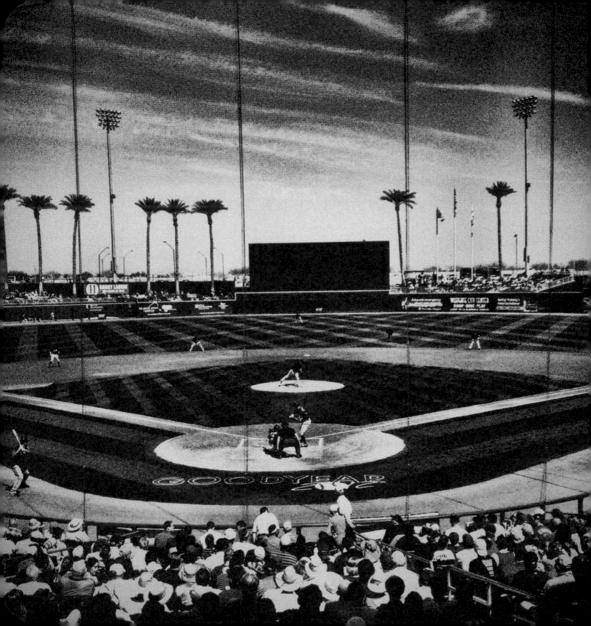

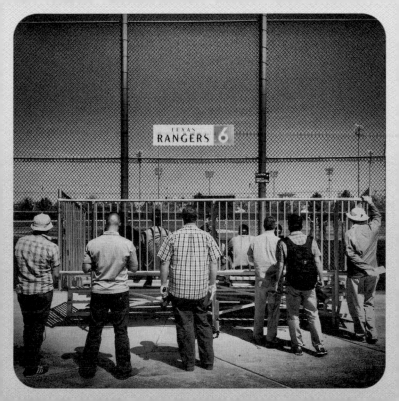

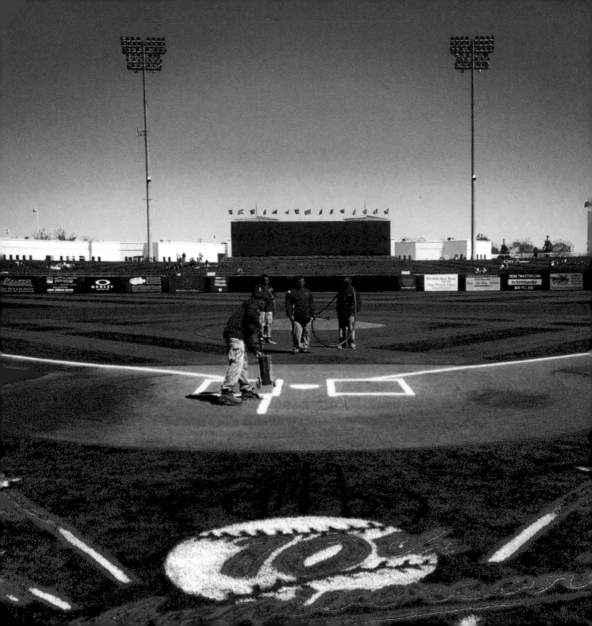

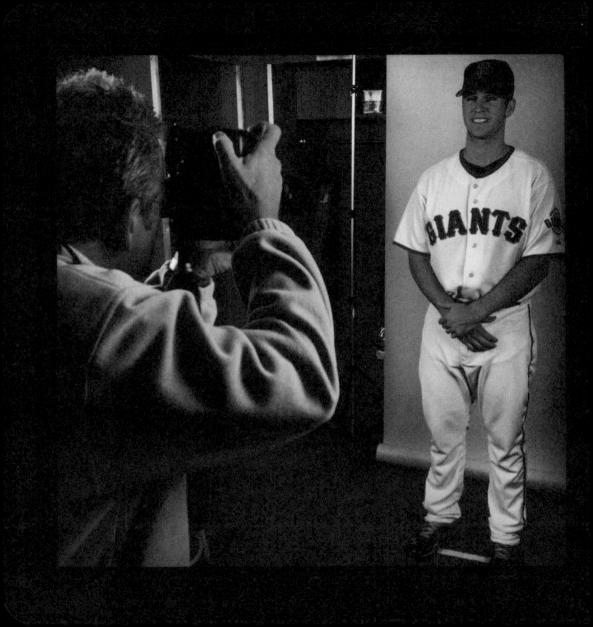

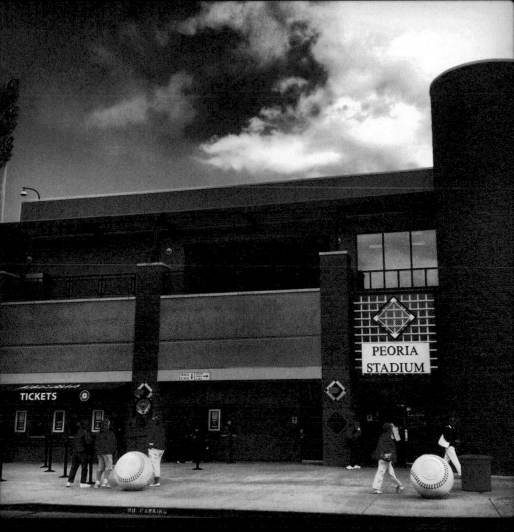

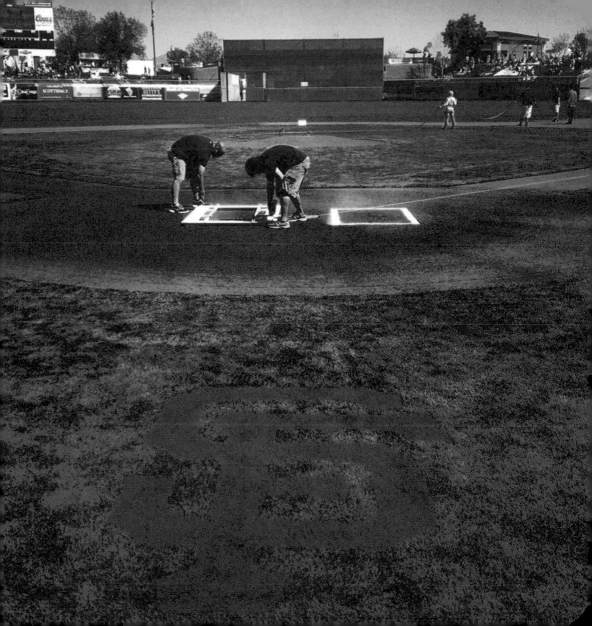

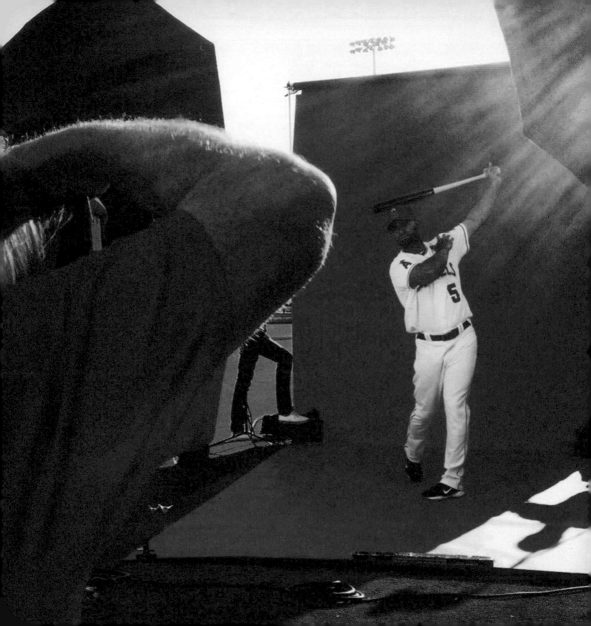

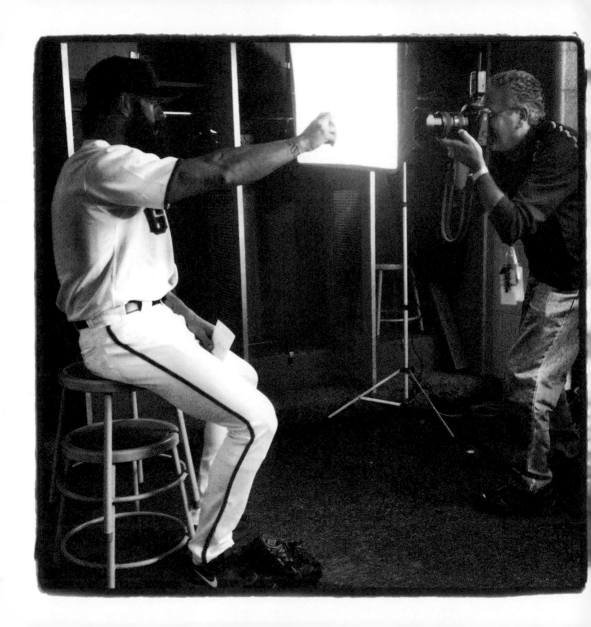

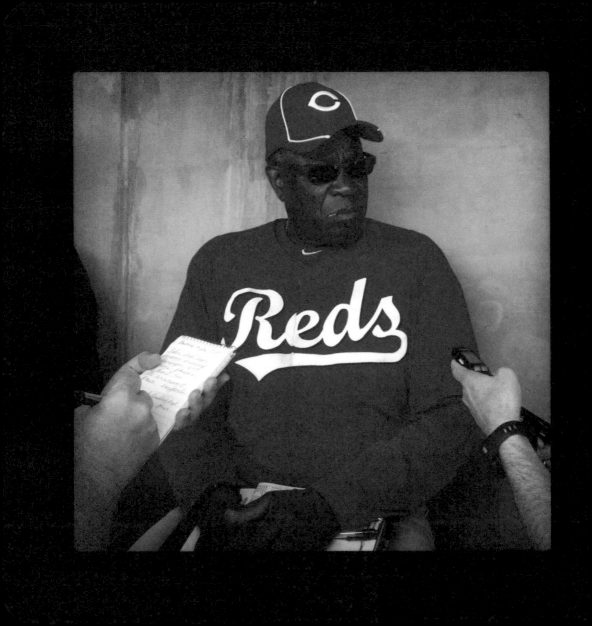

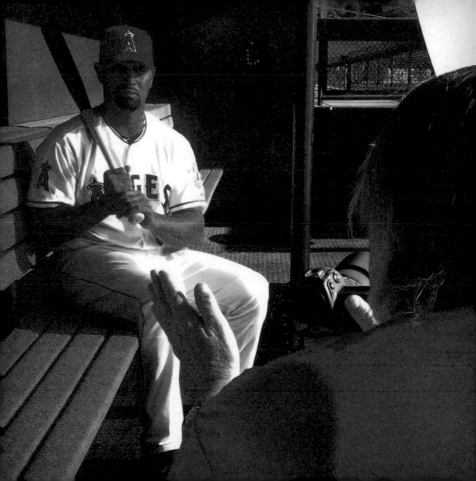

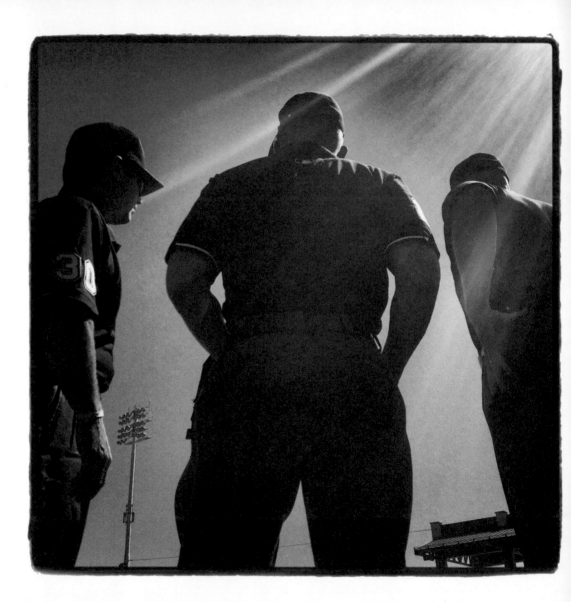

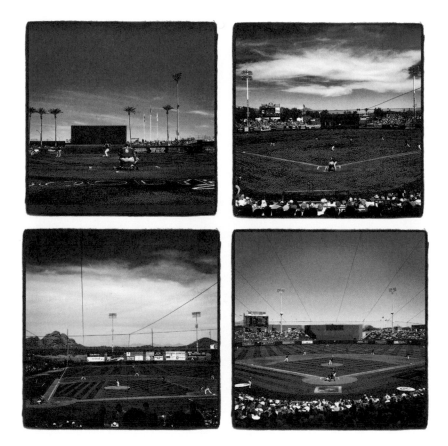

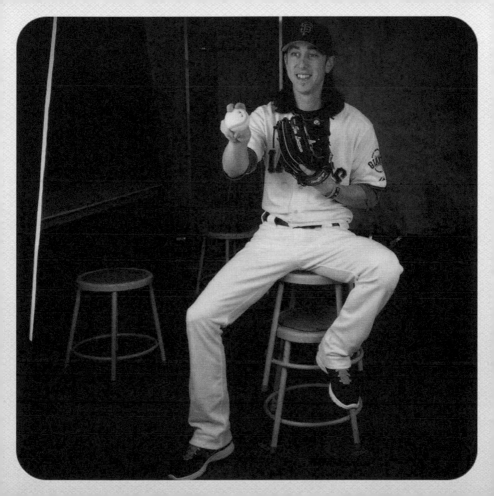

Captions

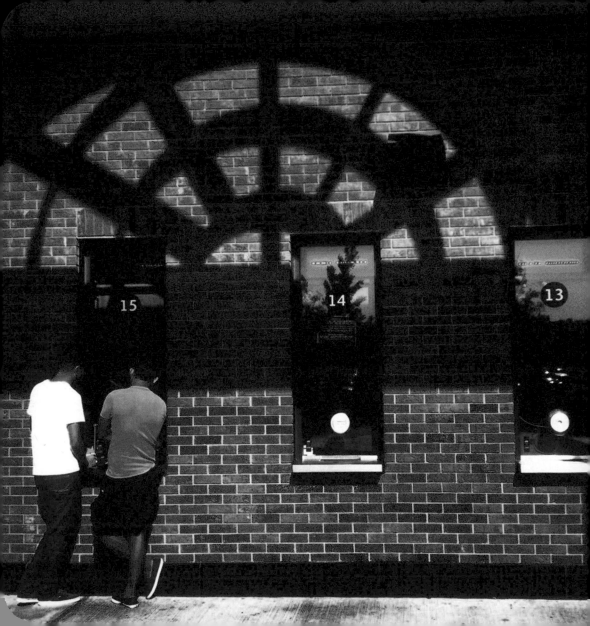

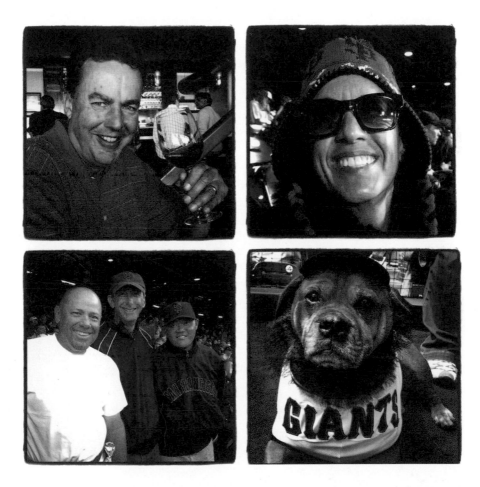

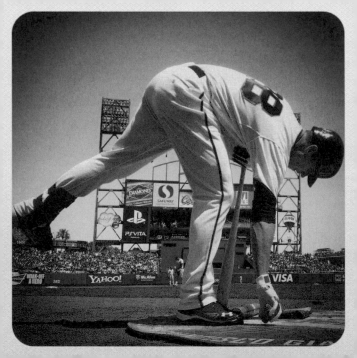

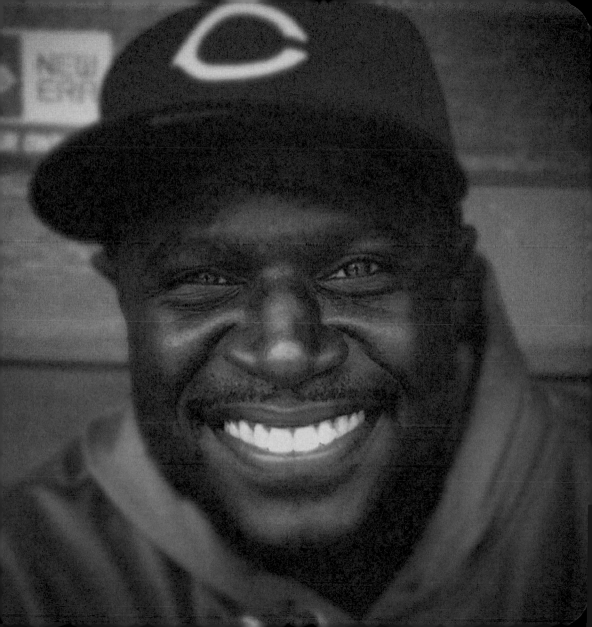

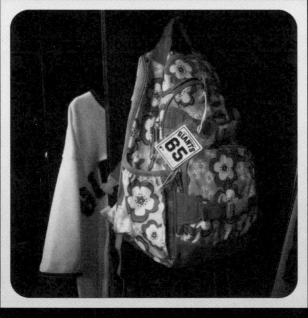

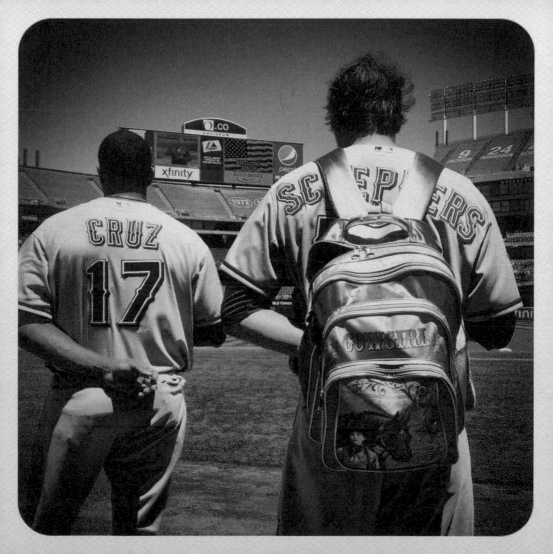

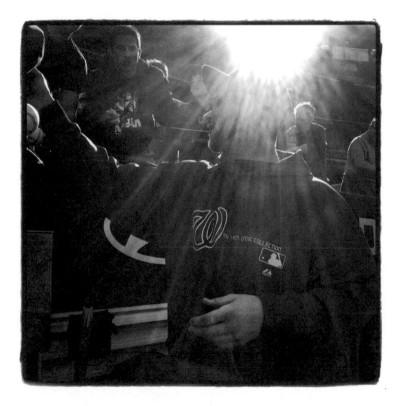

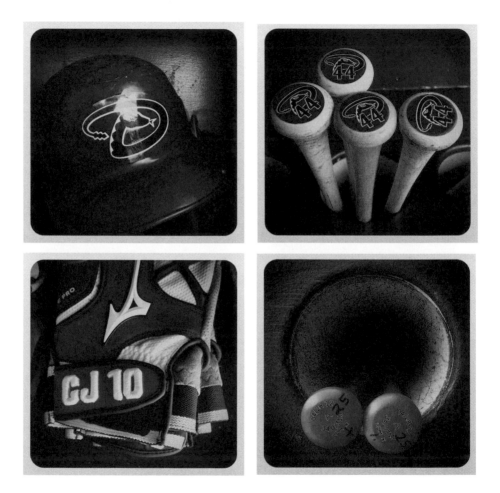

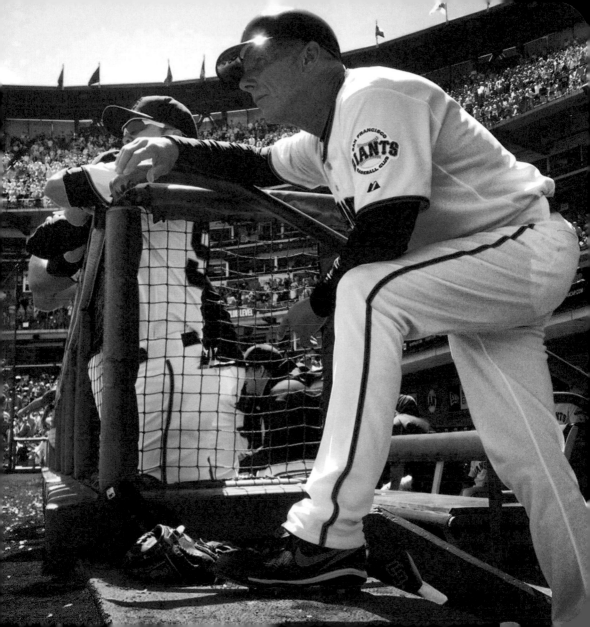

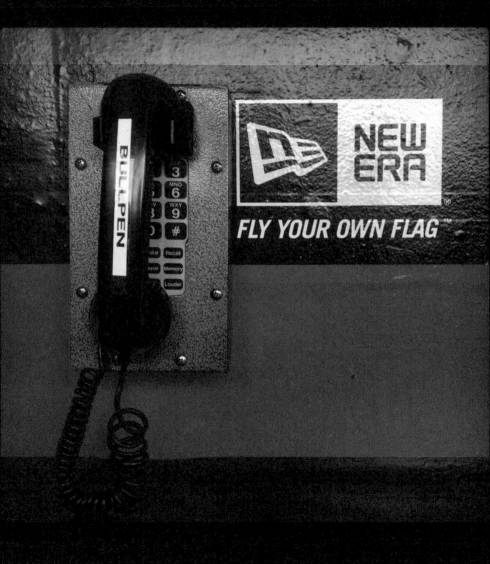

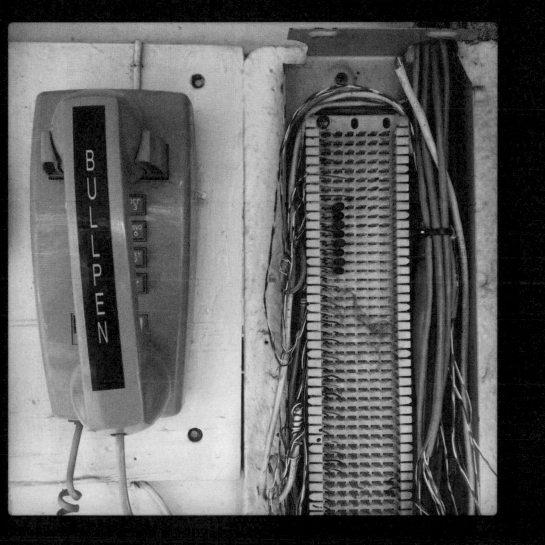

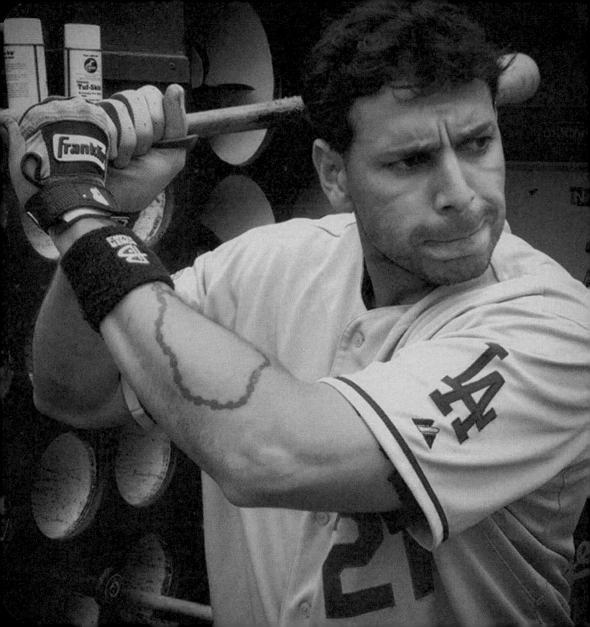

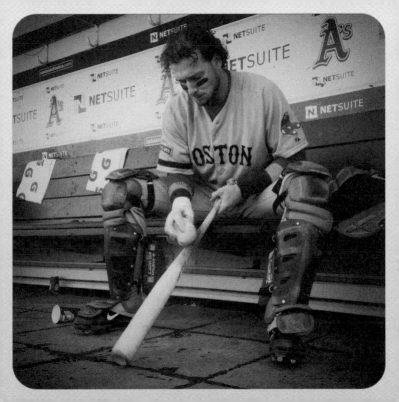

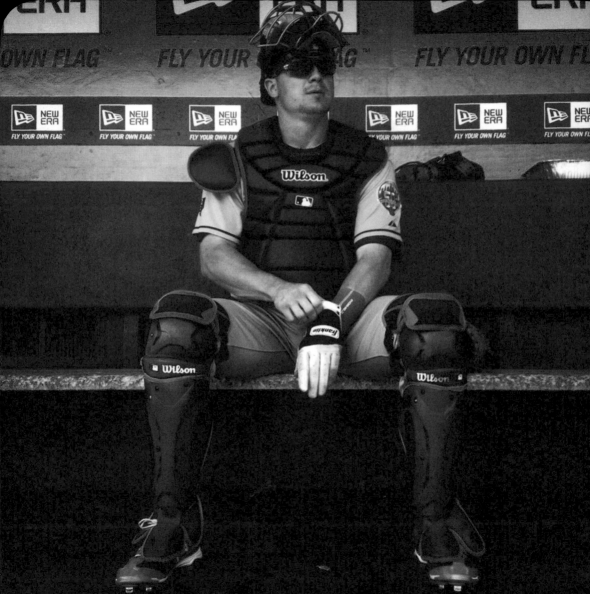

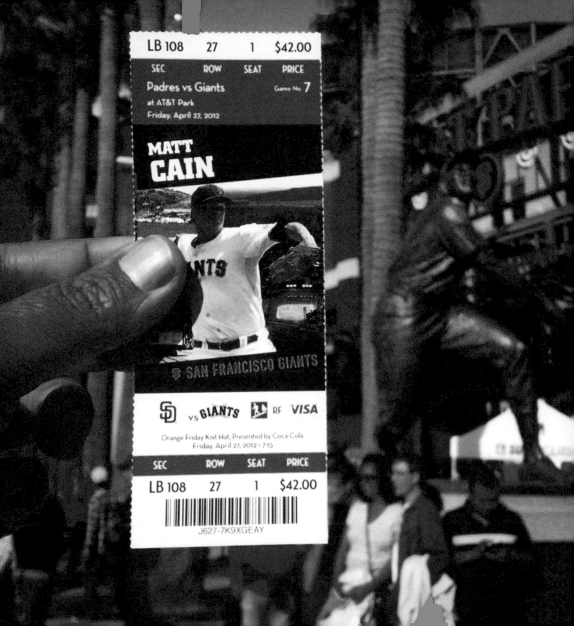

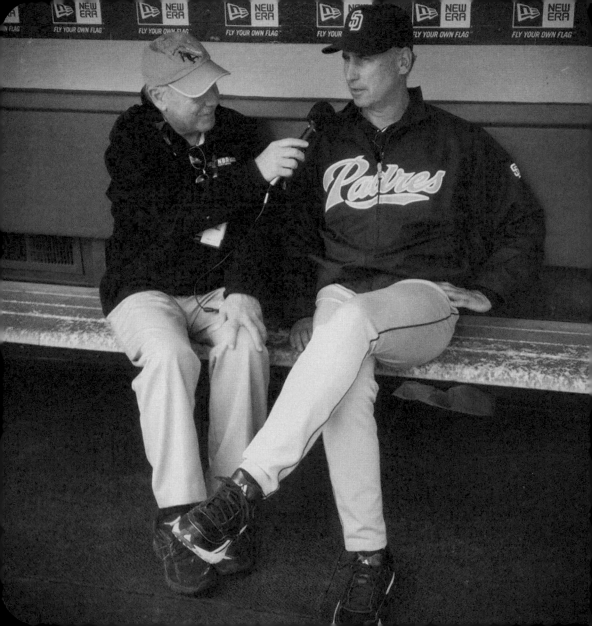

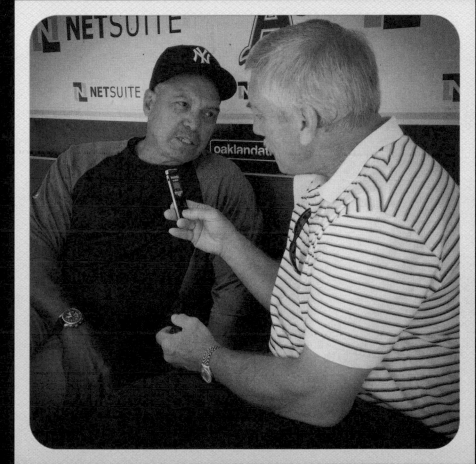

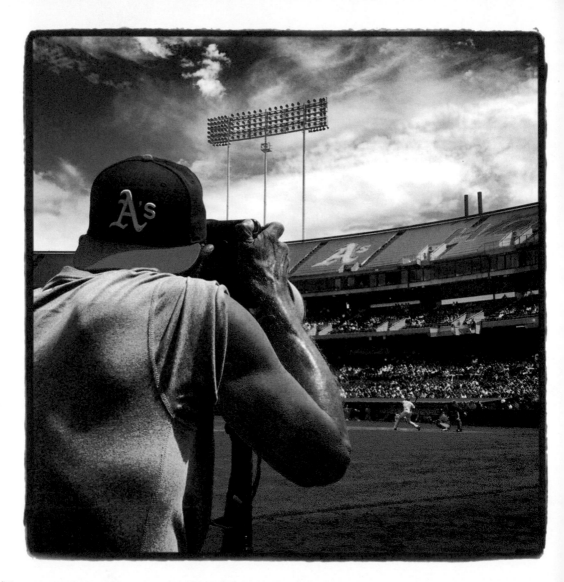

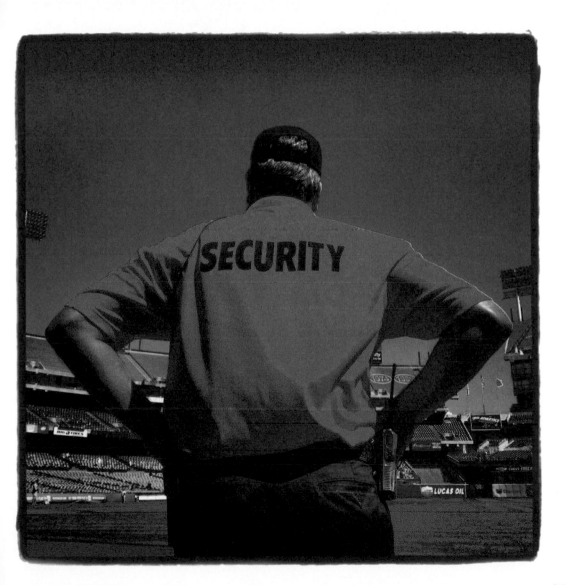

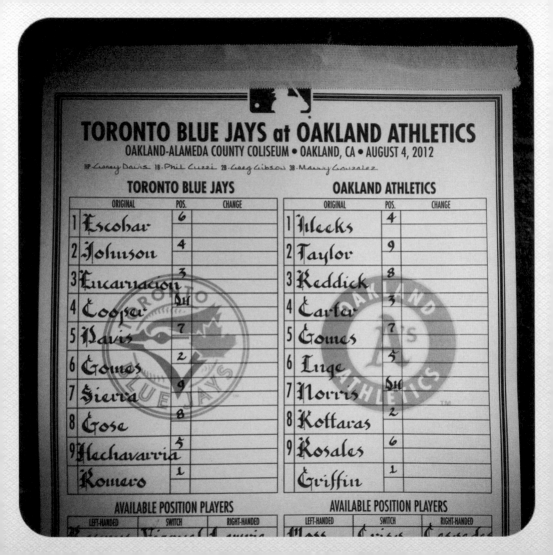

TORONTO BLUE JAYS at OAKLAND ATHLETICS

OAKLAND-ALAMEDA COUNTY COLISEUM • OAKLAND, CA • AUGUST 4, 2012

HP-Gurney Davis 1B-Phil Cuzzi 2B-Greg Gibson 3B-Manny Gonzalez

TORONTO BLUE JAYS

	Original	Pos.	Change
1	Escobar	6	
2	Johnson	4	
3	Encarnacion	3	
4	Cooper	DH	
5	Davis	7	
6	Gomes	2	
7	Sierra	9	
8	Gose	8	
9	Hechavarria	5	
	Romero	1	

OAKLAND ATHLETICS

	Original	Pos.	Change
1	Weeks	4	
2	Taylor	9	
3	Reddick	8	
4	Carter	3	
5	Gomes	7	
6	Inge	5	
7	Norris	DH	
8	Kottaras	2	
9	Rosales	6	
	Griffin	1	

AVAILABLE POSITION PLAYERS

LEFT-HANDED	SWITCH	RIGHT-HANDED
	Vizquel	Lawrie

AVAILABLE POSITION PLAYERS

LEFT-HANDED	SWITCH	RIGHT-HANDED
Moss	Crisp	Cespedes

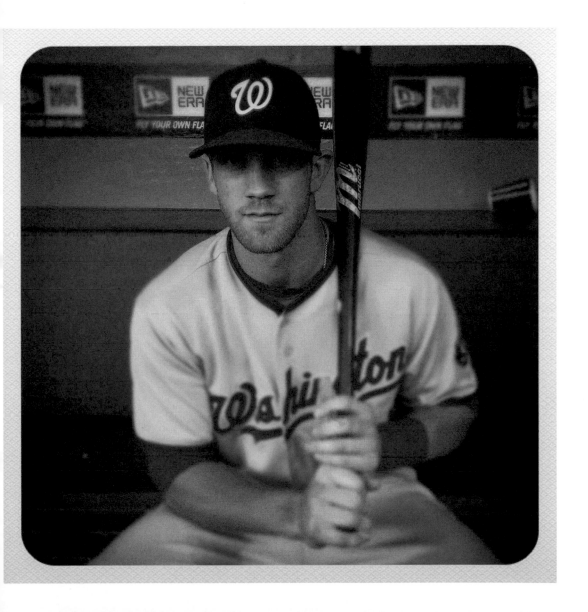

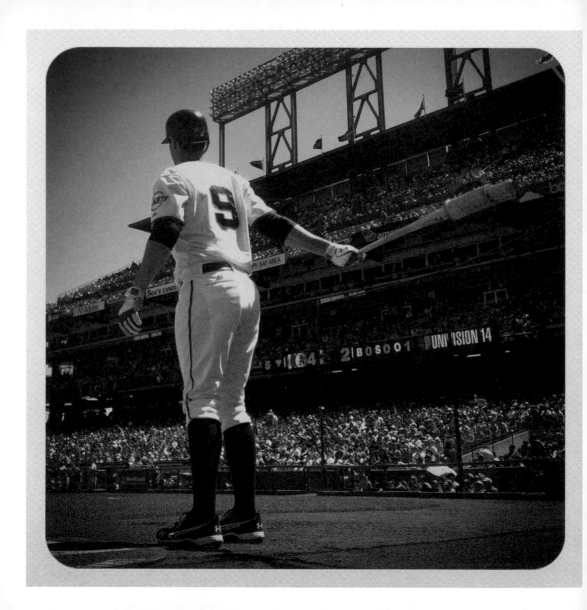

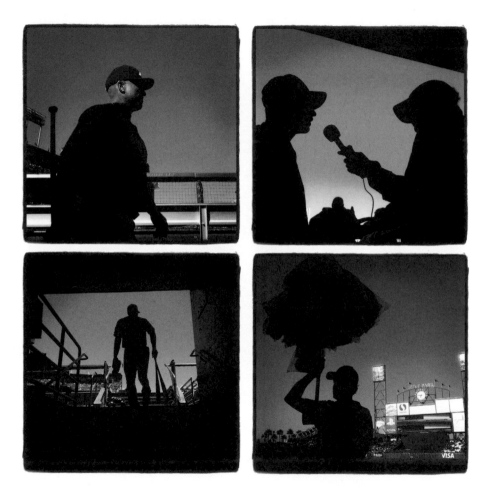

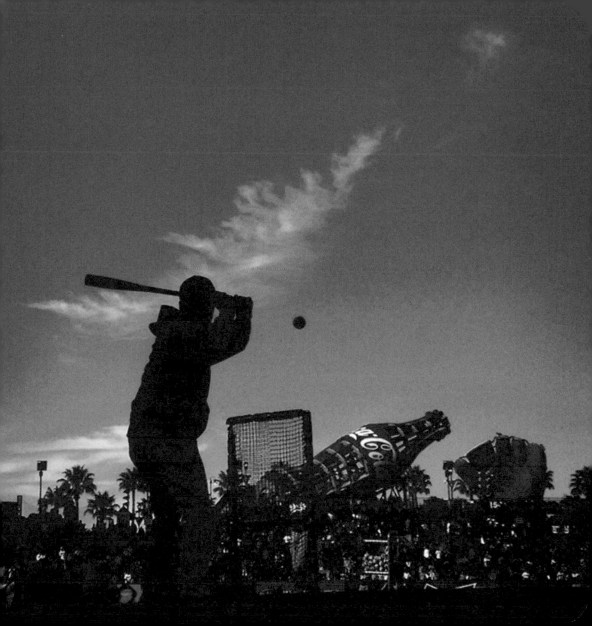

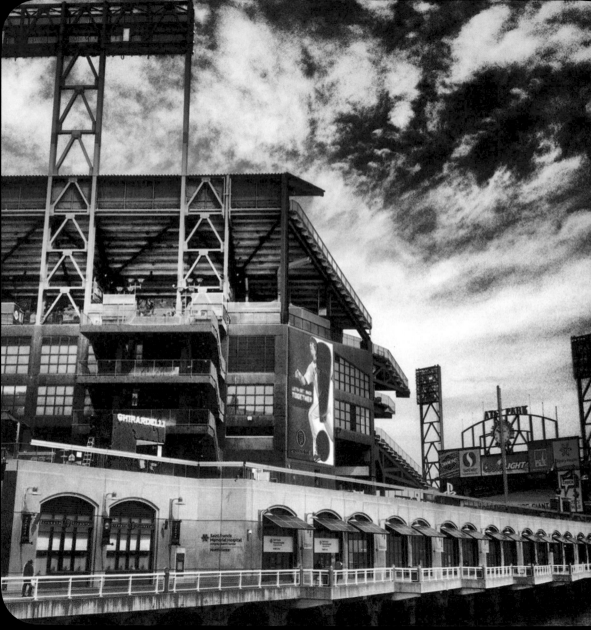

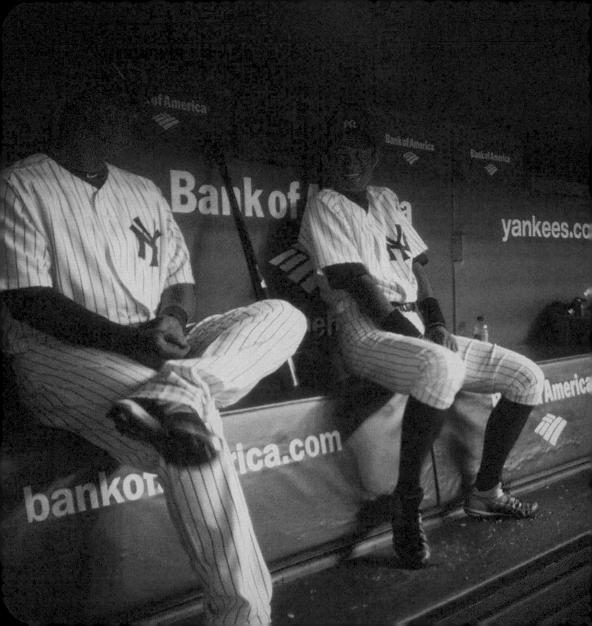

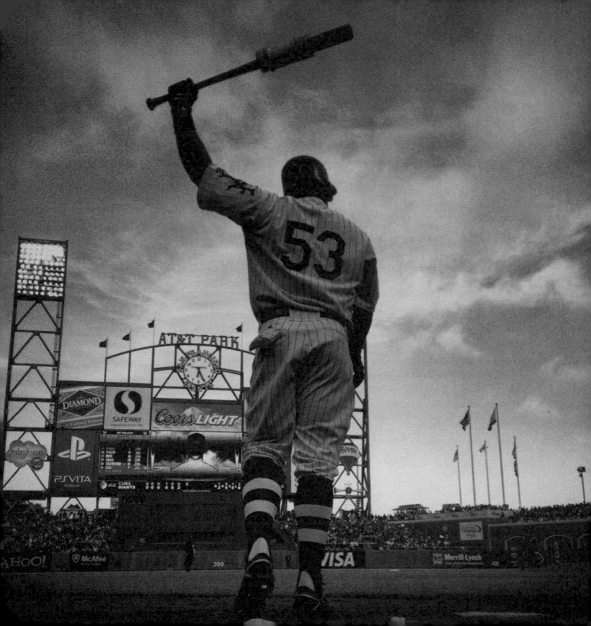

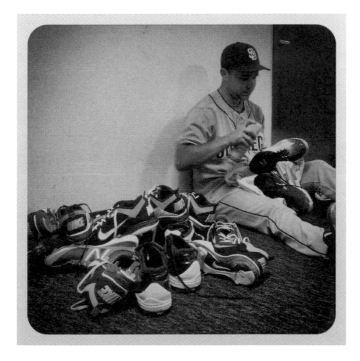

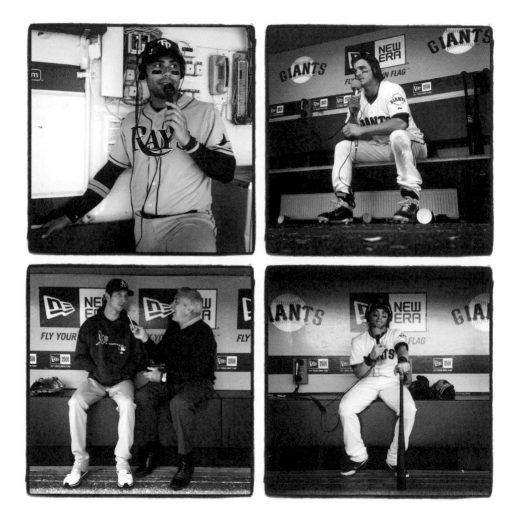

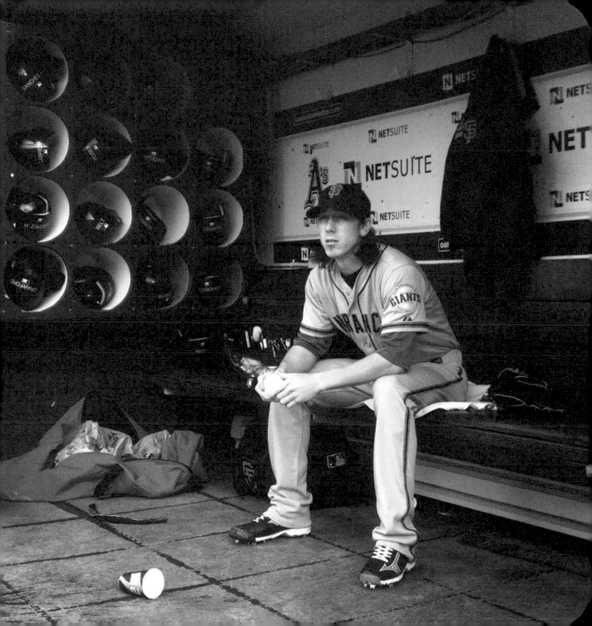

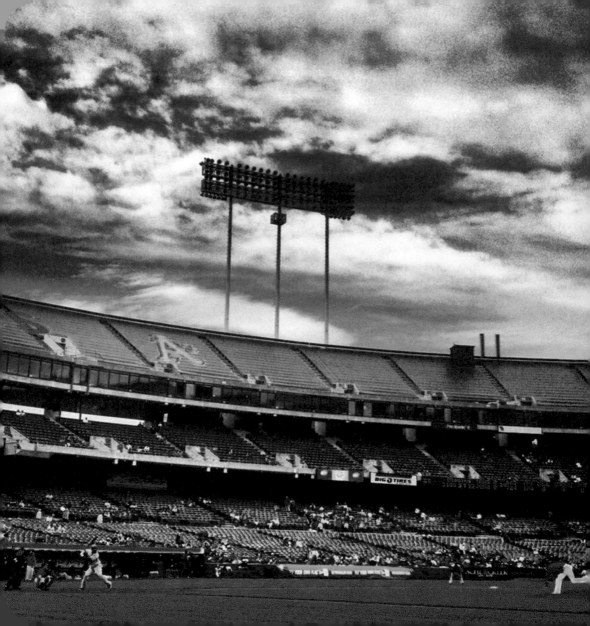

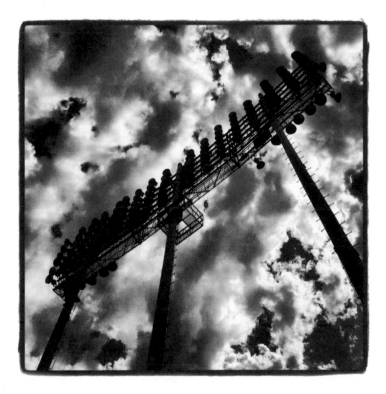

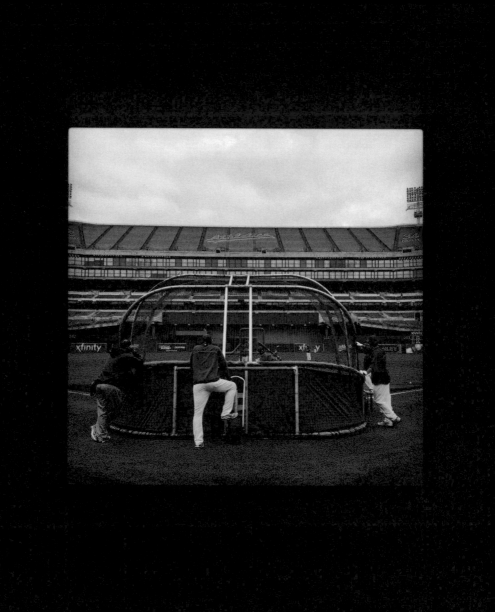

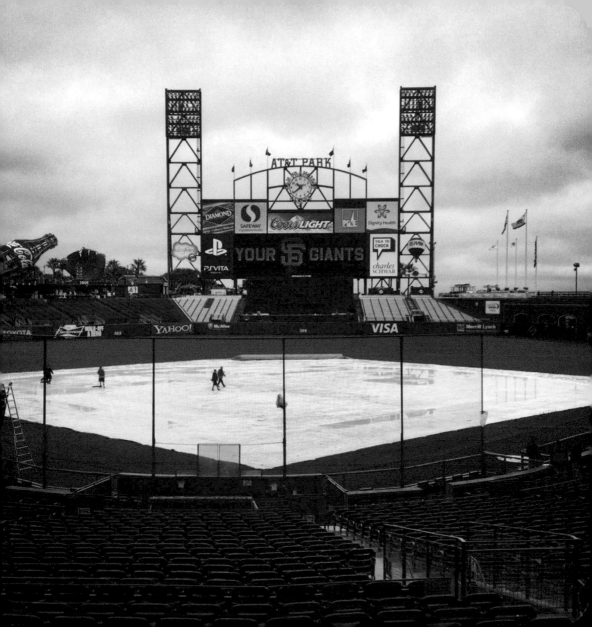

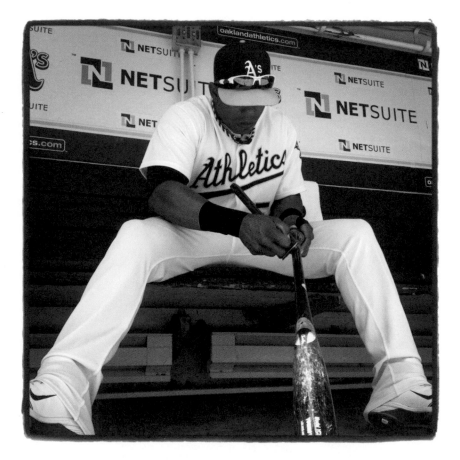

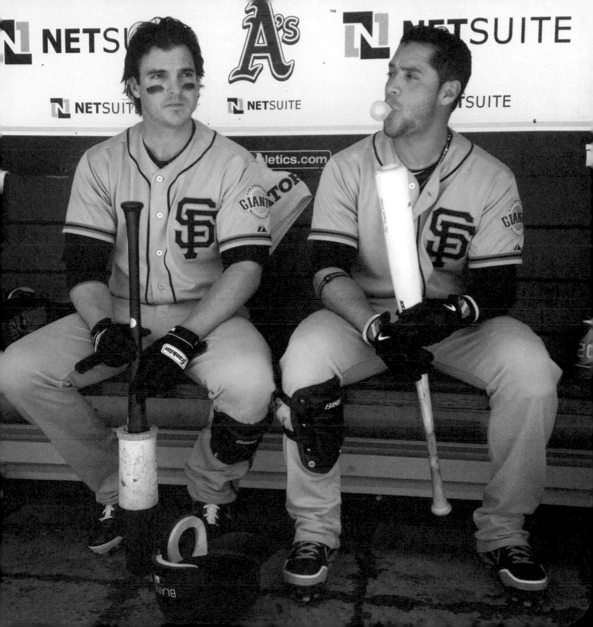

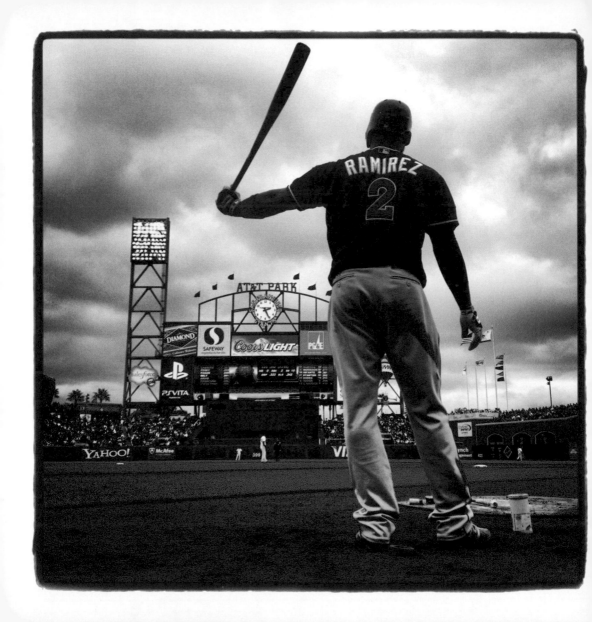

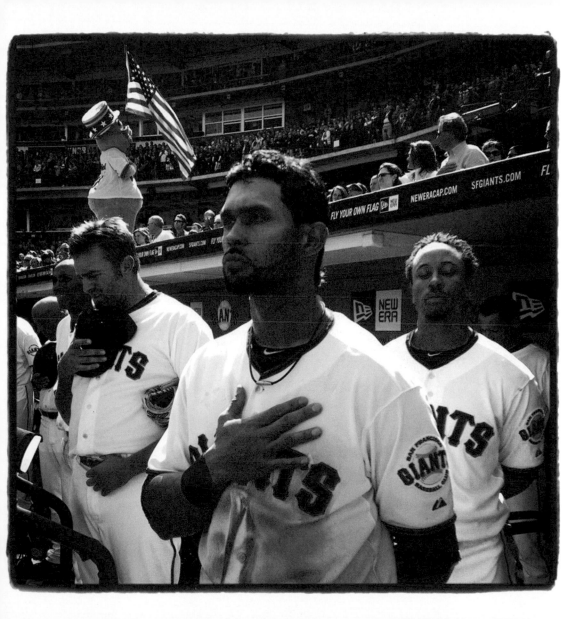

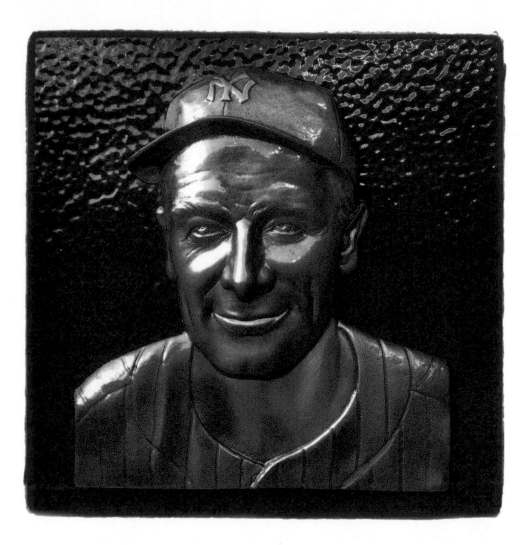

#76

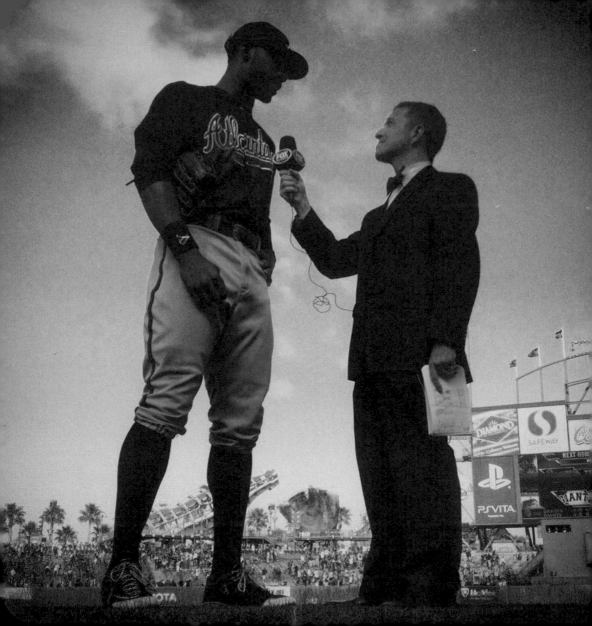

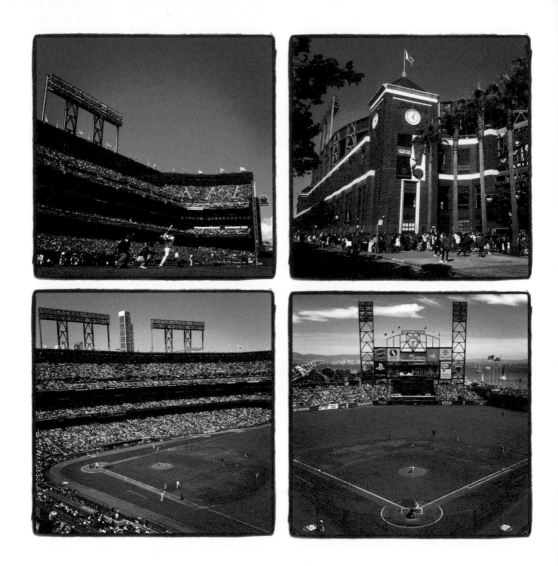

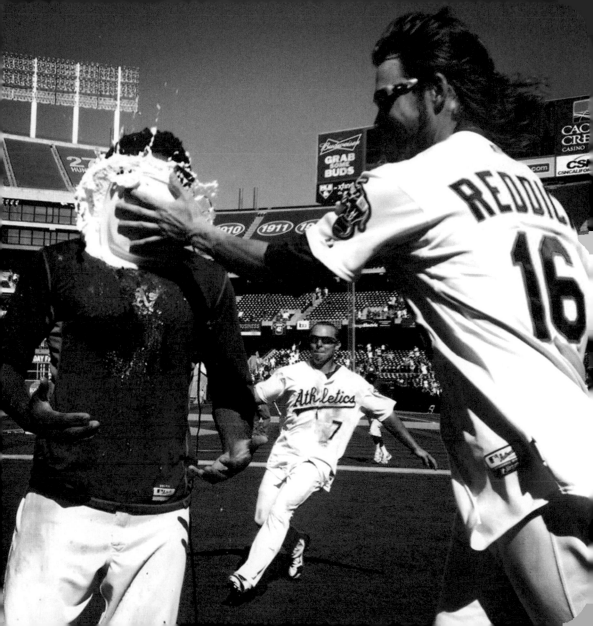

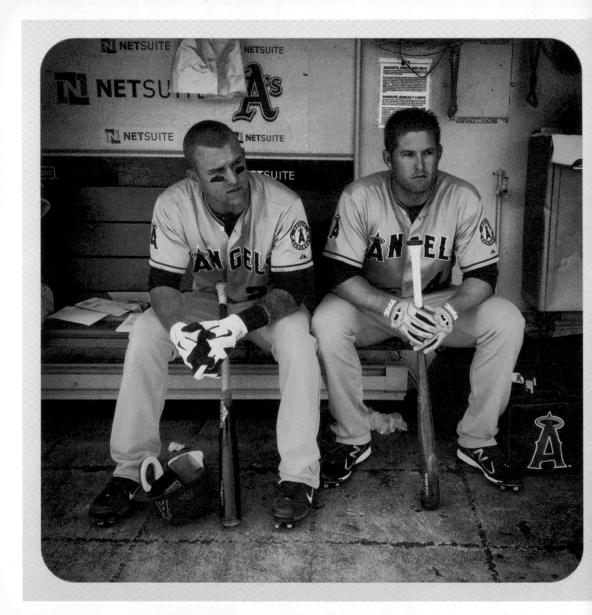

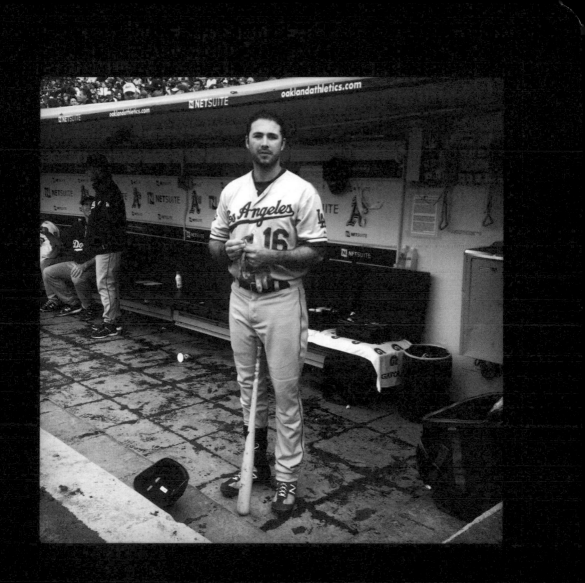

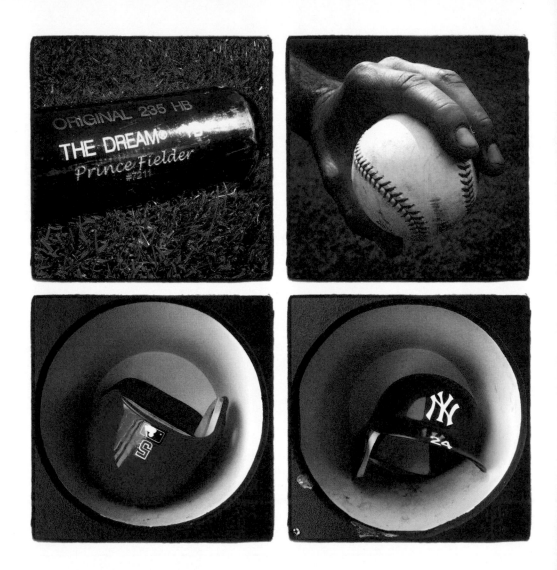

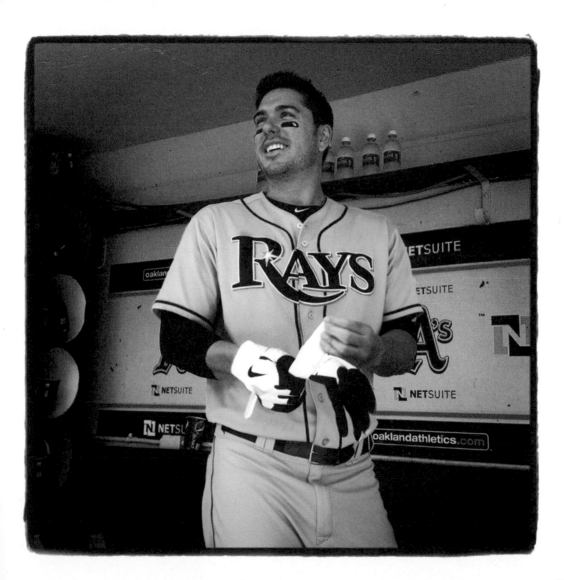

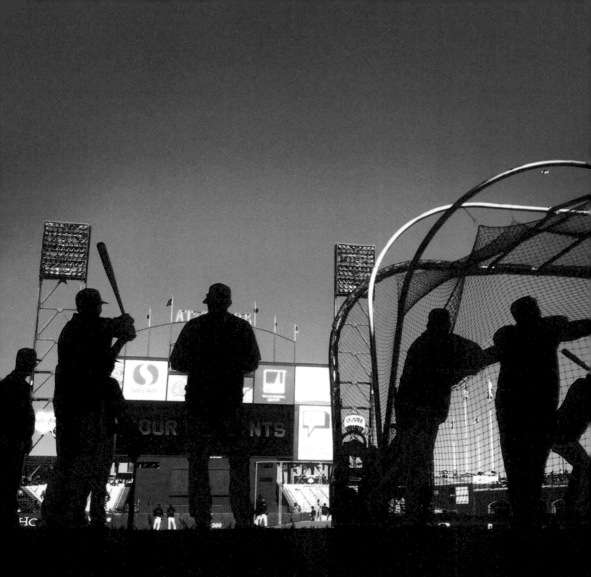

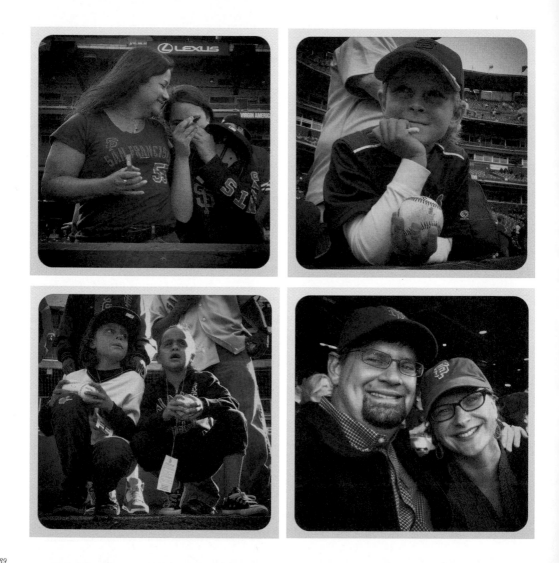

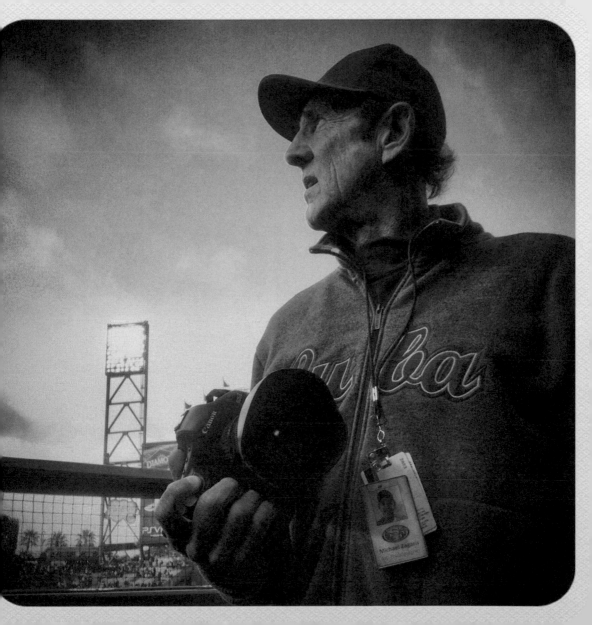

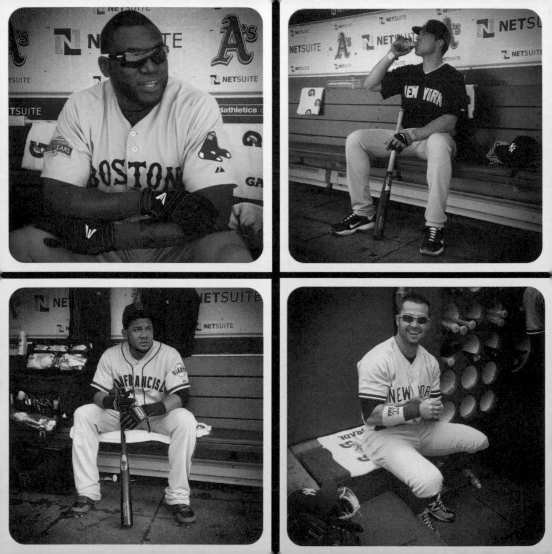

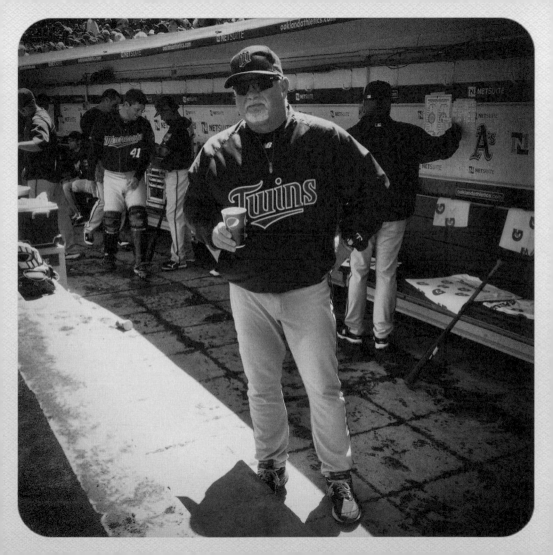

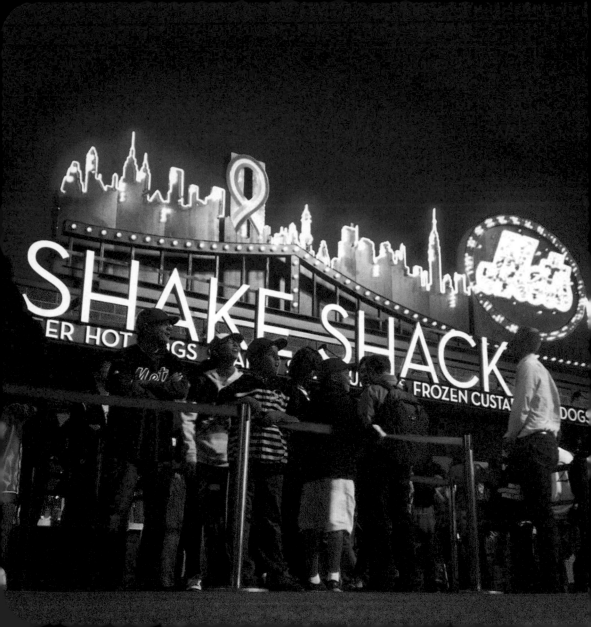

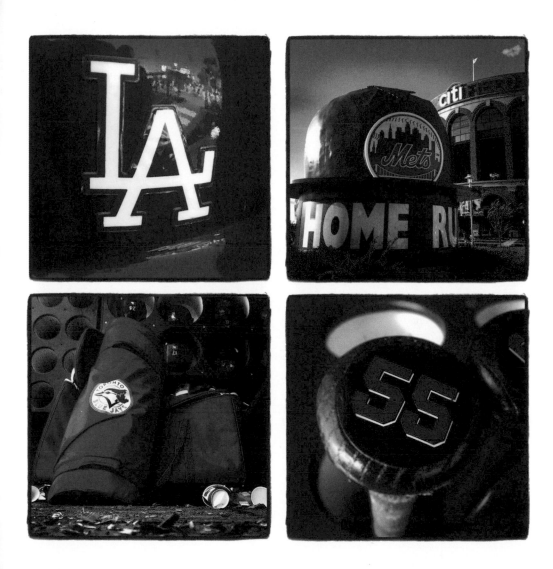

#98

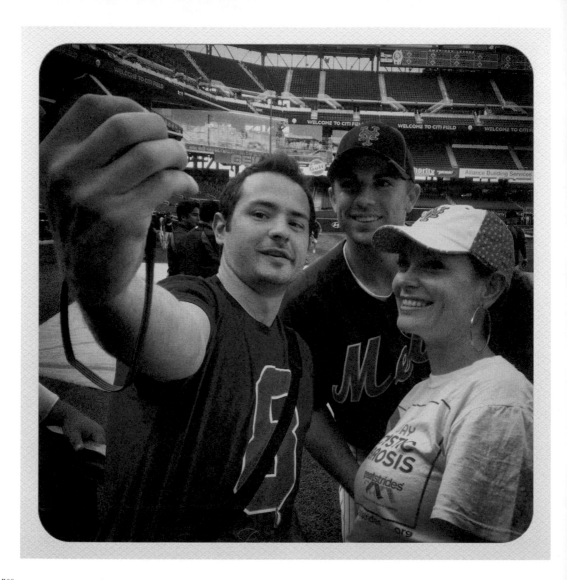

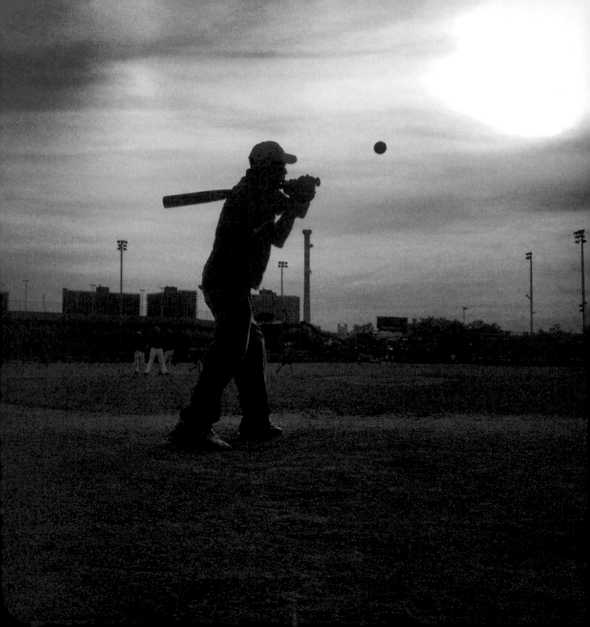

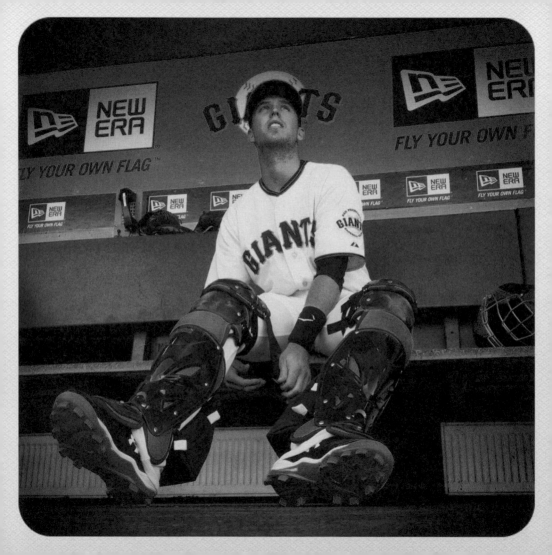

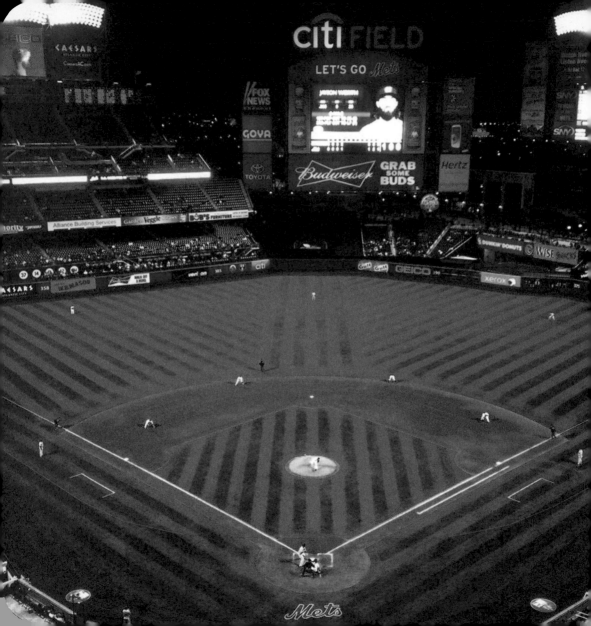

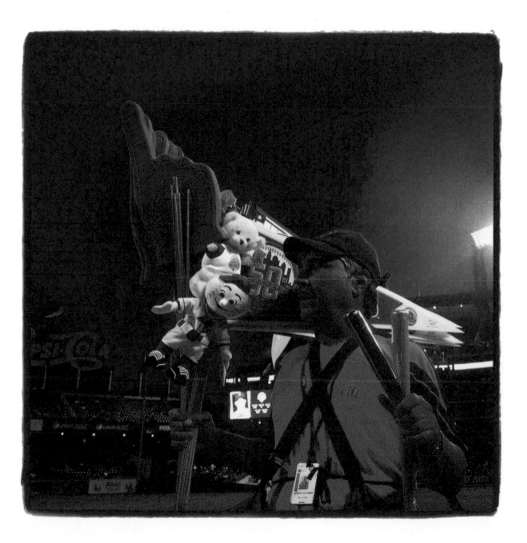

#107

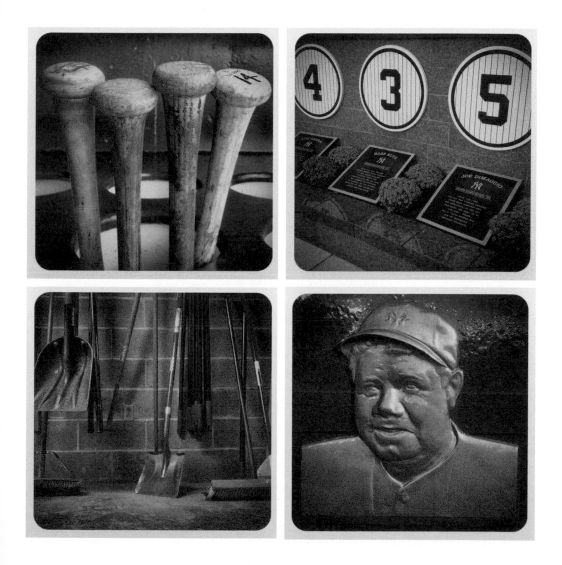

Captions

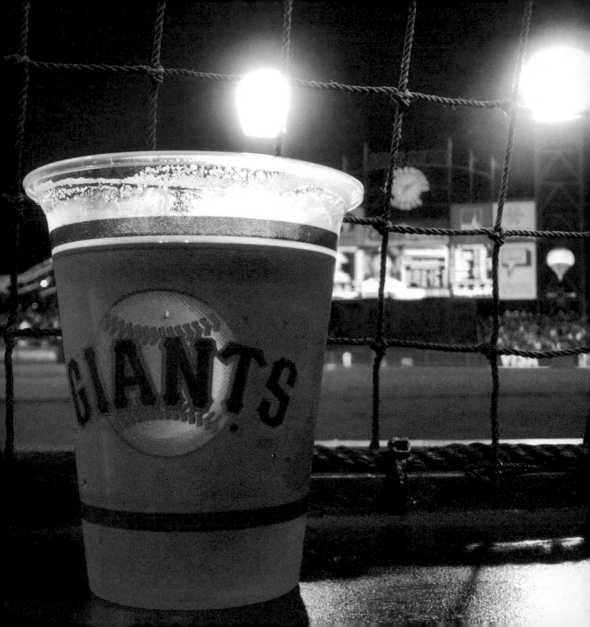

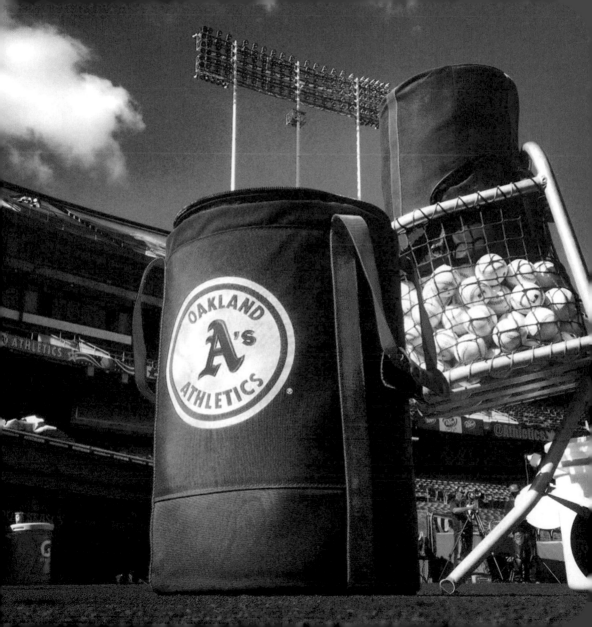

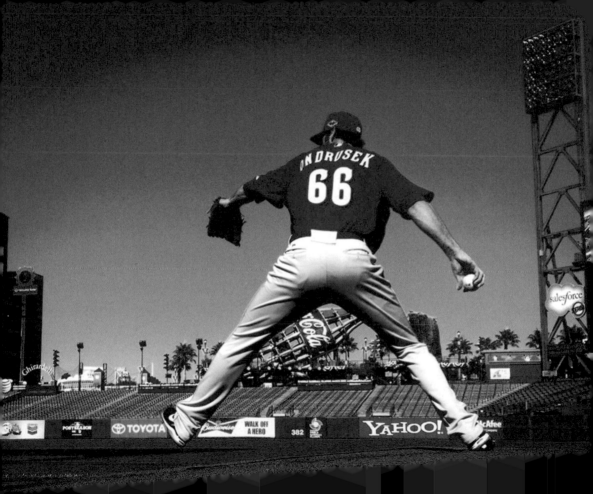

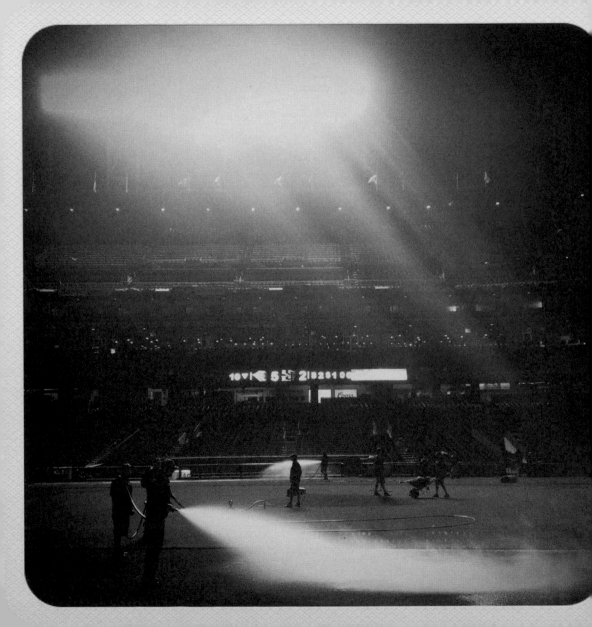

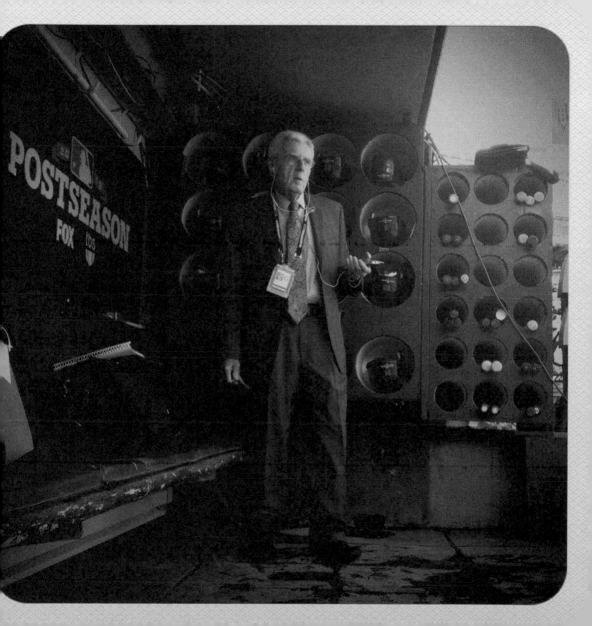

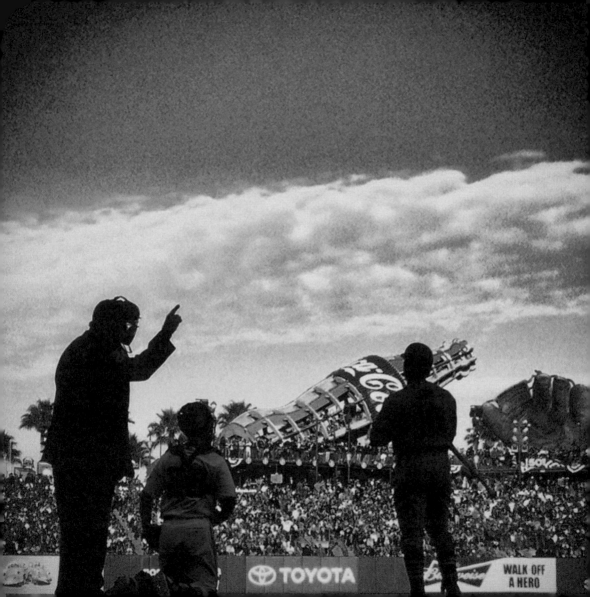

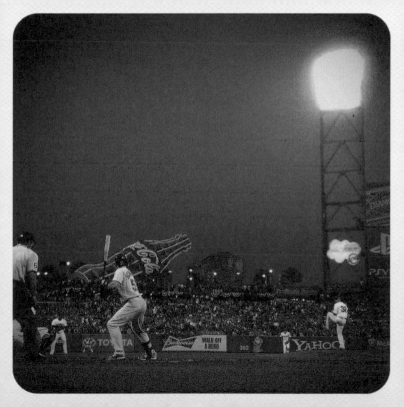

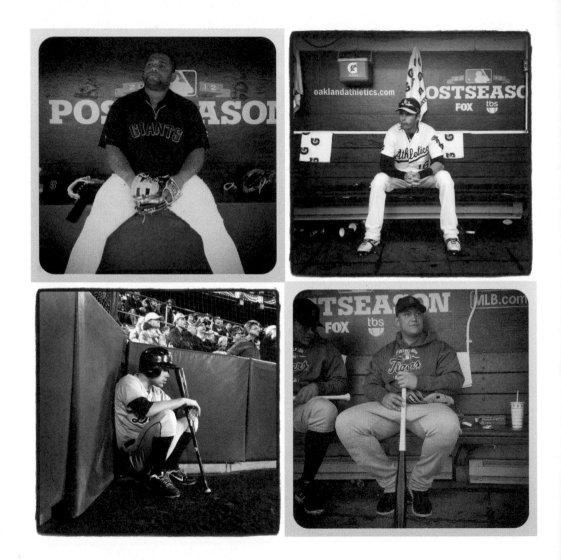

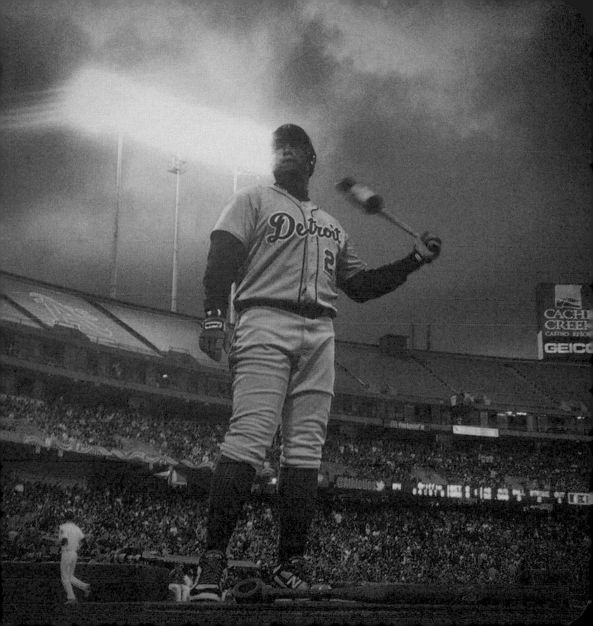

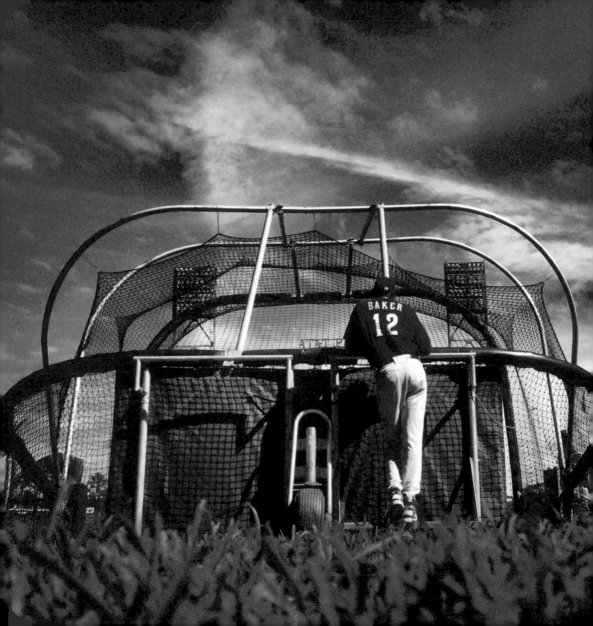

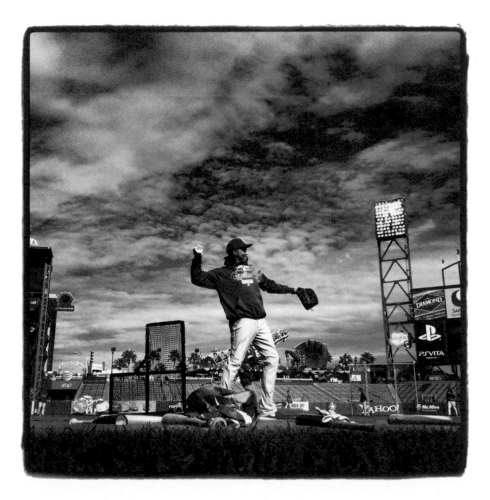

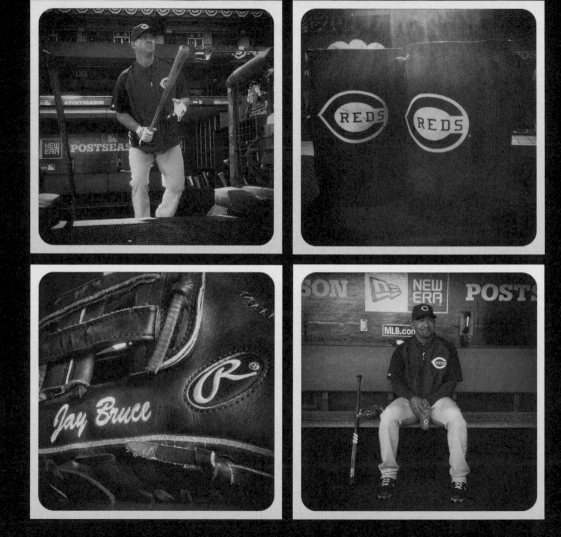

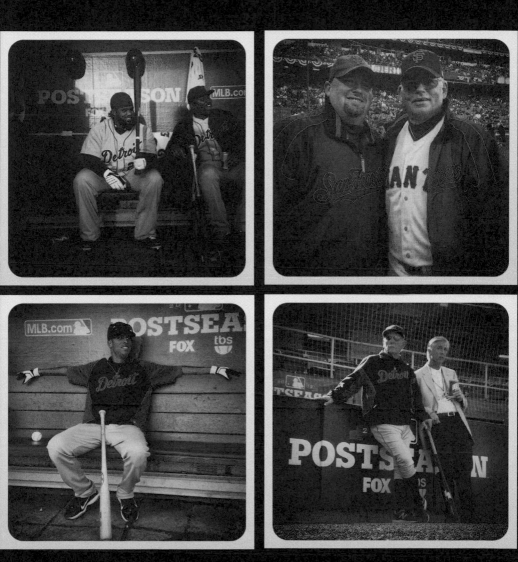

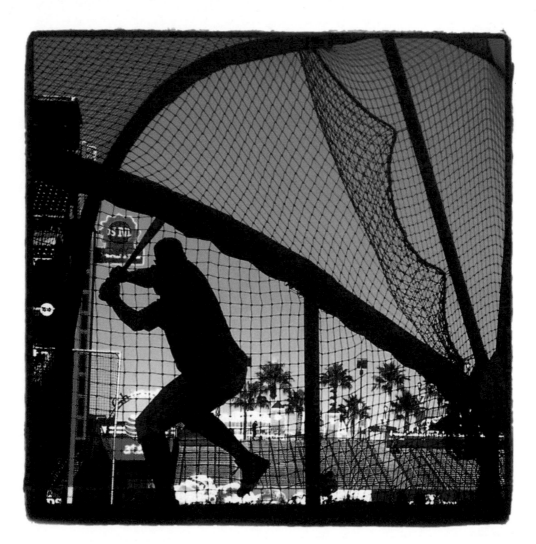

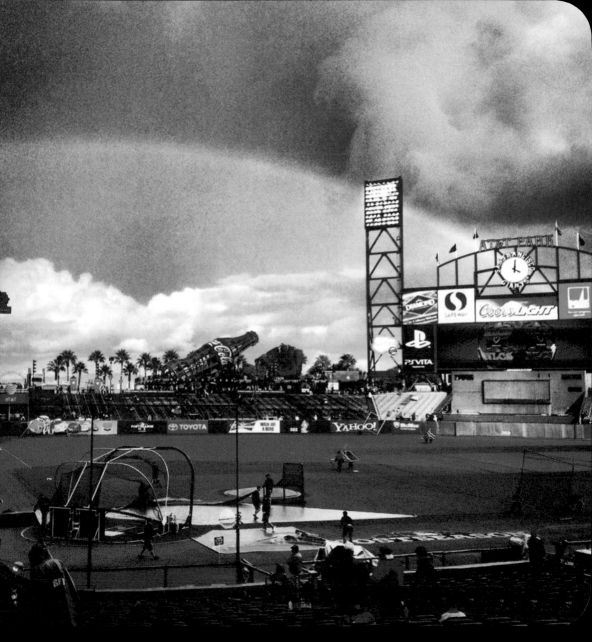

Captions

during a workout [O.co];
LL Quintin Berry (Tigers) works
out [O.co]; NLDS: *UR* Giants ball
dudes Clyde Fralick and Frano
Fralick, pregame [AT&T]

Page 129. NLCS: Pablo Sandoval
(Giants), pregame [AT&T]

Page 130. NLDS: Pablo Sandoval
(Giants) in an indoor cage
[AT&T]

Page 131. NLDS: Brandon Belt
(Giants) takes batting practice
[AT&T]

Page 132. NLCS: *UL* Yadier
Molina (Cardinals), pregame
[AT&T]; NLDS: *UR* A human
"statue" [AT&T]; ALDS:
LR Jonny Gomes (A's) talks to

San Francisco Chronicle sportswriter
Susan Slusser before a game
[O.co]; *LL* Coco Crisp (A's) is
covered with whipped cream after
beating the Tigers [O.co]

Page 133. NLCS: Champagne
for the Giants' National League
Championship [AT&T]

Page 134. NLCS: Before a game
[AT&T]

Page 136. *UR* NLDS: Associated
Press photographer Marcio
Sanchez shoots a workout before
the series [AT&T]; *LR* Discarded
bubblegum wrapper [AT&T]

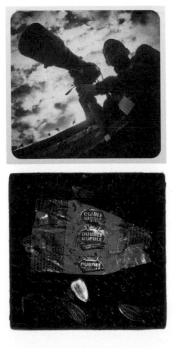

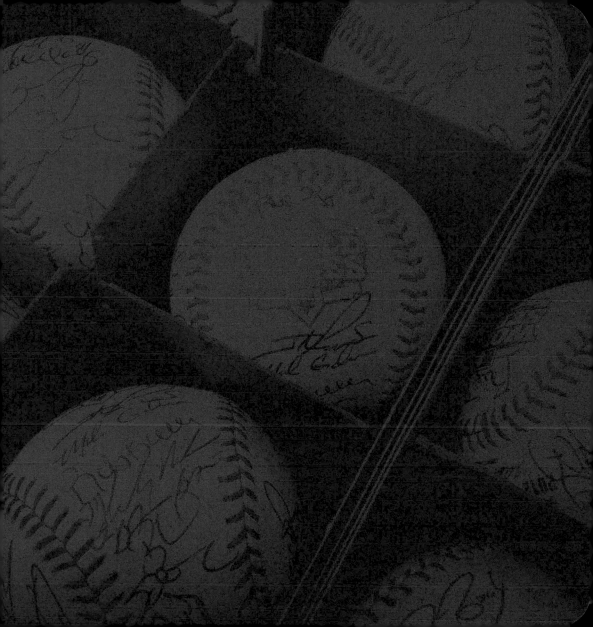

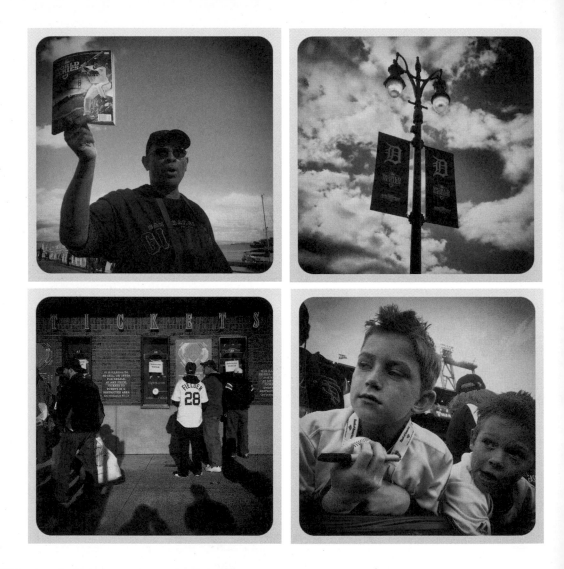

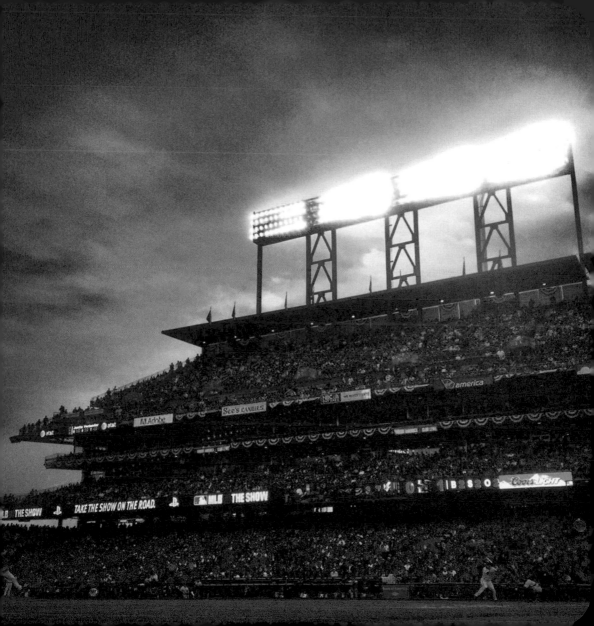

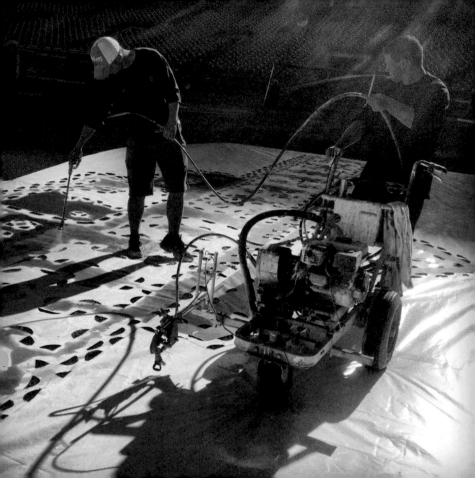

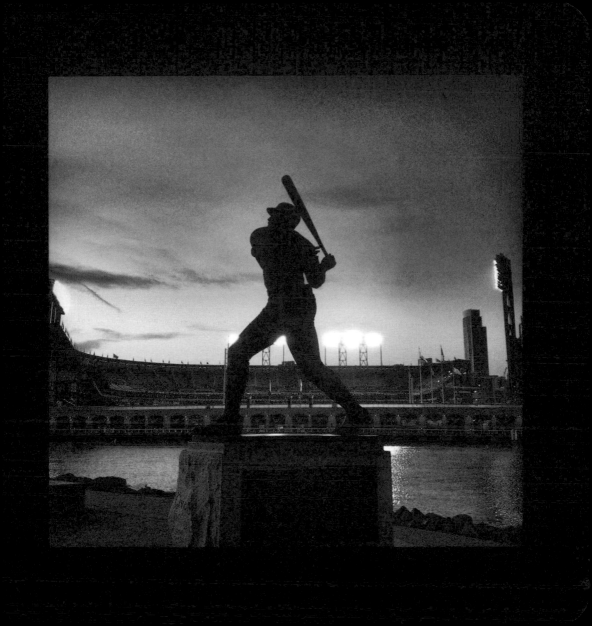

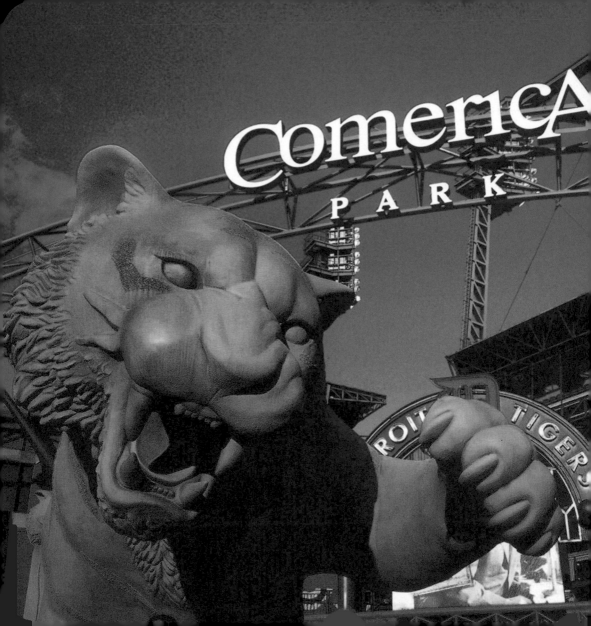

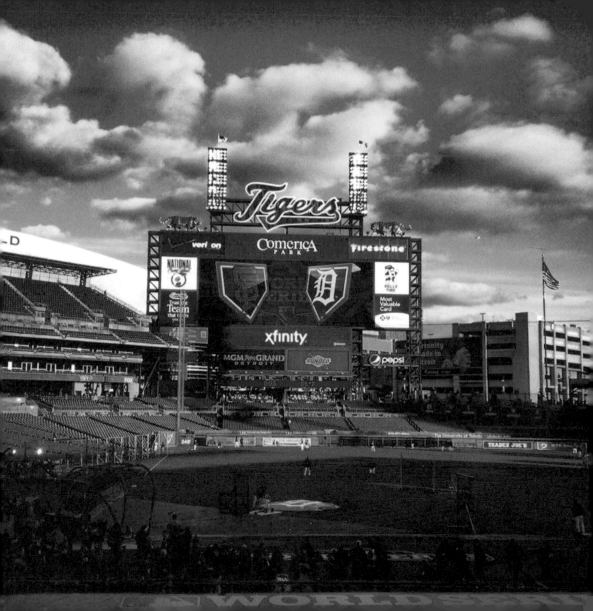

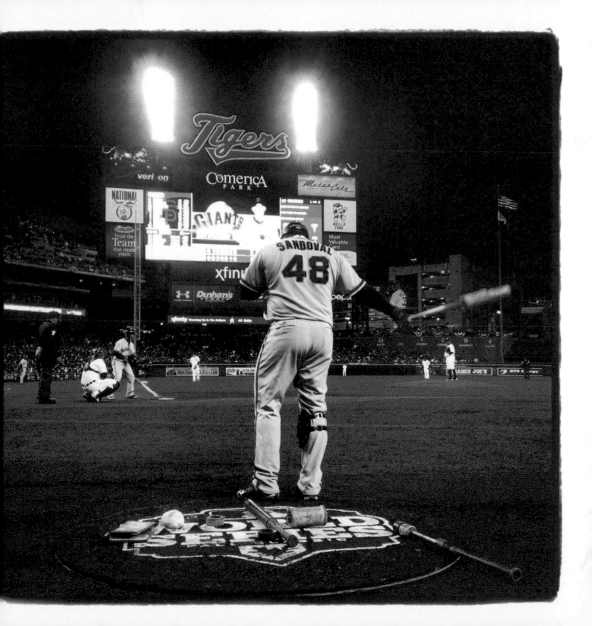

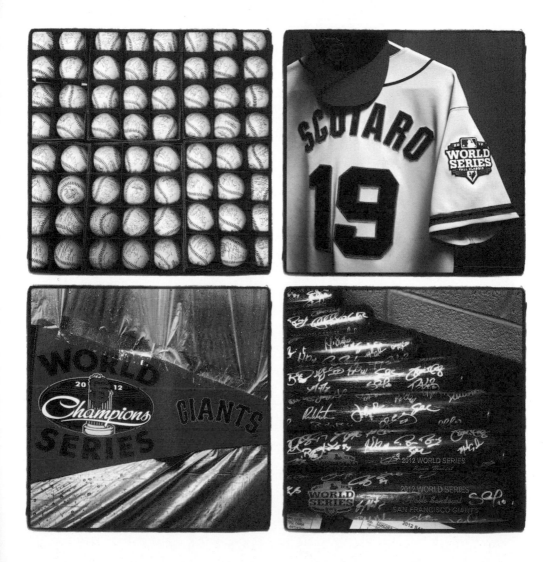

148

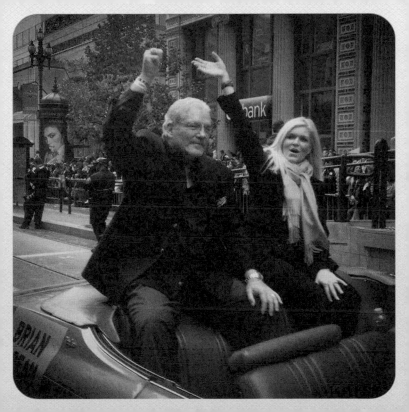

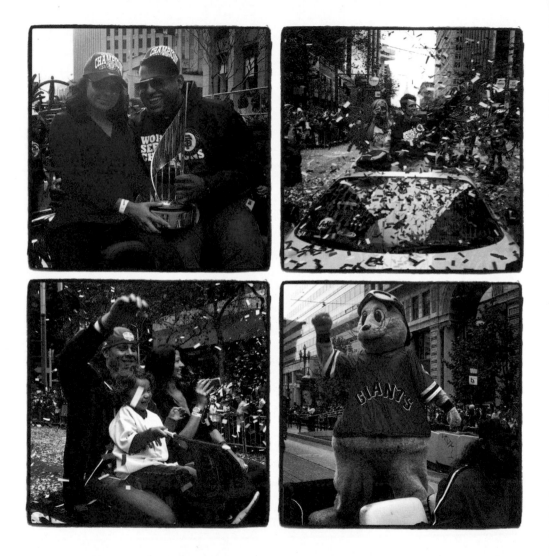

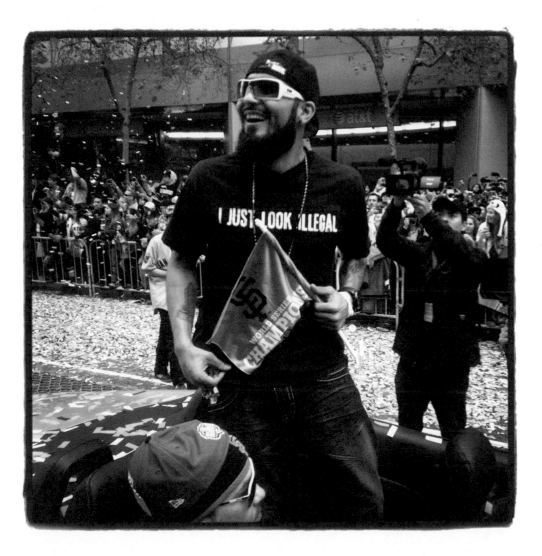

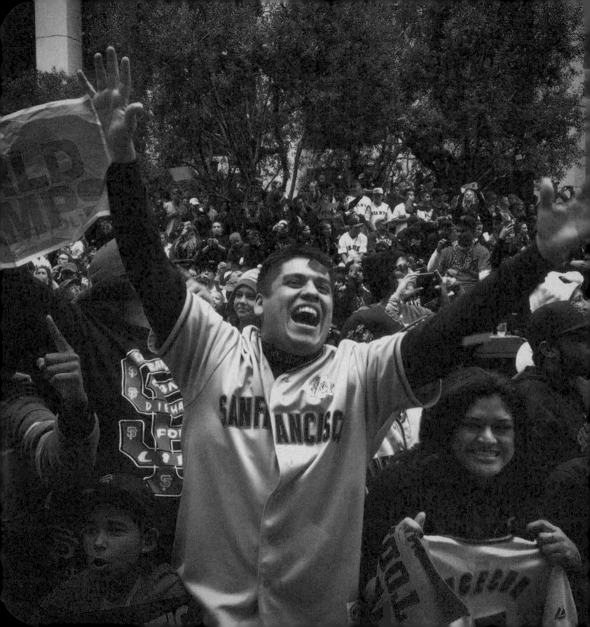

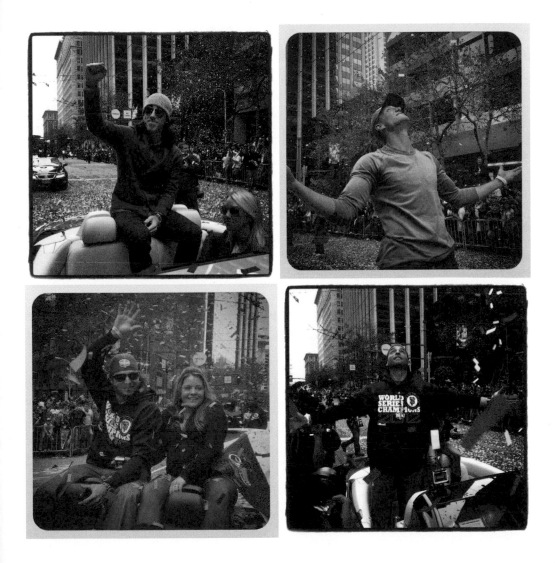

Captions

Page 138. Signed Giants baseballs in their clubhouse [Com]

Page 139. *UL* Selling programs before Game 1 [AT&T]; *UR* In downtown Detroit before Game 3; *LR* Before Game 1 [AT&T]; *LL* Fans pick up tickets before Game 3 [Com]

Page 140. Justin Verlander (Tigers) pitches in Game 1 [AT&T]

Page 141. Grounds crew the day before Game 1 [AT&T]

Page 142. Statue of Giant immortal Willie McCovey [AT&T]

Page 143. [Com]

Page 144. The Tigers take batting practice before Game 3 [Com]

Page 145. *UL* Postgame party in Detroit; *UR* Gala in Detroit; *LR* Brandon Crawford's Giants jersey before Game 4 [Com];

LL On-deck circle [AT&T]

Page 146. Pablo Sandoval (Giants) waits on deck during Game 4 [Com]

Page 147. Gala in San Francisco

Page 148. In the Giants clubhouse: *UL* Signed baseballs [Com]; *UR* Marco Scutaro's jersey [Com]; *LR* Signed bats [Com]; *LL* Giants' World Series Championship pennant after Game 4 [Com]

Page 149. Giants manager Bruce Bochy meets the press before Game 4 [Com]

Page 150. The Giants victory parade in San Francisco: General Manager Brian Sabean and his wife, Amanda

Page 151. *UL* Pablo Sandoval shows off his World Series MVP trophy; *UR* Buster Posey and his wife, Kristen; *LR* Giants mascot

Lou Seal; *UR* Ryan Vogelsong with wife, Nicole, and son, Ryder

Page 152. Sergio Romo

Page 153. The fans go crazy

Page 154. *UL* Tim Lincecum; *UR* Hunter Pence; *LR* Marco Scutaro; *LL* Brandon Crawford and his wife, Jalynne

Page 156. Brad Mangin in the Giants dugout before Game 1; photo by Jed Jacobsohn

Page 158. Justin Verlander (Tigers) warms up before Game 5 of the ALDS [O.co]

Page 160. Giants World Series Championship champagne [Com]

Page 161. McCovey statue [AT&T]

Biographies

Brad Mangin (@bmangin) is a freelance sports photographer based in the San Francisco Bay Area, where he regularly shoots assignments for *Sports Illustrated* (nine covers thus far) and Major League Baseball Photos, from the first pitch of spring training to the final out of the World Series (the last thirteen to date). Brad graduated from San Jose State University in 1988 with a degree in photojournalism. His

work experience has ranged from being a staff photographer at the *Contra Costa Times* to working for the legendary sports photographer Neil Leifer at *The National Sports Daily* as San Francisco's staff photographer. He began his fulltime freelance career in 1993.

Brad has donated his entire archive of baseball photographs, dating back to 1987, to the National Baseball Hall of Fame and Museum in Cooperstown, New York. This collection grows each day during the season with every new game he shoots.

Mangin's first book of photographs, *Worth the Wait*, the official commemorative book of the San Francisco Giants 2010 World Series season, was published in March of 2011.

The son of Cuban refugees, Pedro Gomez learned baseball at age three from his grandfather, a former umpire in the Cuban Winter League. He spent most of his first ten years in Detroit and eventually grew up in Miami. Gomez covered the Oakland A's from 1990 to 1997 for the *San Jose Mercury News* and *Sacramento Bee*, then moved to Phoenix, where he became national baseball writer at the *Arizona Republic*, and where he still resides with his wife and three children. In 2003, he became a general assignment reporter for ESPN's *SportsCenter*, specializing in baseball. He has covered fifteen World Series and ten All-Star Games to date.

Technical Specs

All of the Instagrams in this book were shot with the native camera and lens in my Apple iPhone 4s. All editing and toning to the images was done within the iPhone, using a few of my favorite iPhone apps.

The apps I used most of the time were Dynamic Light and Snapseed. I really love Snapseed for converting images to black and white and for toning the images. Dynamic Light is my favorite app for making a sky look dramatic and for adding great color to images. Once I get the image to look the way I want I import it into Instagram. Once in Instagram I usually apply the Lo-fi filter and border if I want high contrast and rich color, or rich black and white. If I want muted colors with an old-school look, or if I want to make a black and white image into sepia toned I use the Earlybird filter and border. The third filter that I occasionally use is Hefe when I want a warm tone and thick black border.

For example, I shot this picture of Justin Verlander warming up in the Tigers bullpen under dark and stormy skies knowing it would make for a great black and white Instagram. I then processed it in Dynamic Light to make the clouds really stand out, then ran the image through Snapseed to convert it into black and white and darken it a little bit. The final step was to bring it into Instagram to produce the final image by adding the Lo-fi filter to give it the high-contrast feel I was looking for.

As I shot over the baseball season I realized that my phone battery would not last for an entire day. To fix this problem I bought a Mophie Juice Pack rechargeable battery case. This case saved my life and allowed me to use my phone all day and night without needing a charge.

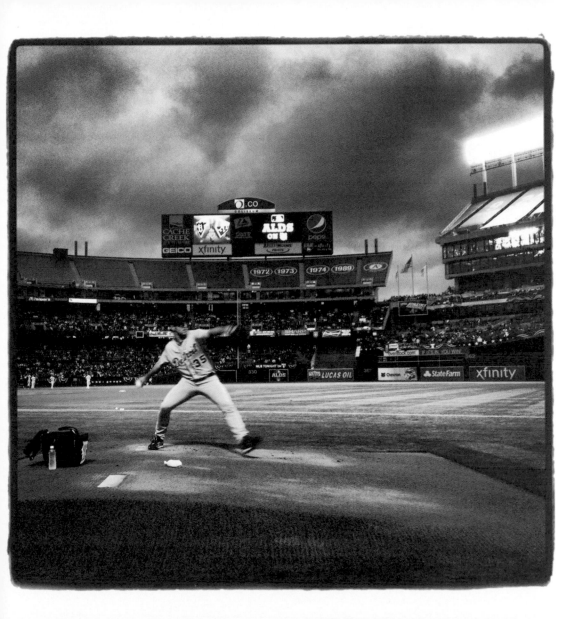

Acknowledgments

I would like to dedicate this book to my dad for teaching me to love baseball, and to my mom for teaching me how to see.

Thanks to publisher Chris Gruener (@chris gruener), editor Mark Burstein, and designer Iain Morris from Cameron + Company for having the faith in me to publish this book. I am blessed to be able to work with such a great team.

I am indebted to my brilliant literary agent, Amy Rennert, who worked so hard to get this book published so that my dream of having a book illustrated with Instagrams could become a reality.

Thanks to the photo department at *Sports Illustrated* led by Director of Photography Steve Fine (@stevefine). Steve and picture editor Nate Gordon took a chance and first published my baseball Instagrams in the weekly magazine, proving to the world that I was onto something pretty cool.

My gratitude is also due to Jessica Foster and Jim McKenna at Major League Baseball Photos.

Bob Rose, Debbie Gallas, and Michael Zagaris of the Oakland A's have made shooting games at the Coliseum such a joy.

Jim Moorehead, Maria Jacinto, Andy Kuno (@misterandy), Staci Slaughter (@stacislaughter), and Bryan Srabian (@srabegram) of the San Francisco Giants helped make covering the 2012 Giants so much fun.

New York Mets photographer Marc Levine (@msimages) was an incredible host and worked his magic getting R. A. Dickey to pose for me.

New York Yankees photographers Ariele Goldman Hecht (@ariele326) and Matthew Ziegler (@mattyz123) welcomed me with open arms into the big ballpark in the Bronx and took great care of me during my visit.

Zack Arias (@zarias) inspired me so much during the dog days of summer. His enthusiasm encouraged me to get off my ass and go back out to Queens to get R. A. Dickey's knuckleball grip.

I was blessed to have many wonderful teachers: Paul Ficken, Terry Smith, Gerry Mooney, Joe Swan,

and Jim McNay.

Neil Leifer has always been there for me and was the first to call when he saw six pages of my Instagrams in *Sports Illustrated*.

Pedro Gomez did a terrific job of introducing this book.

Matt Maiocco (@maioccocsn) took me to see Matt Cain's perfect game in San Francisco and photographed me with my ticket stub after the game with, of course, my iPhone.

Jed Jacobsohn (@jedphoto) has been so much fun to work with this year, and he photographed me with his iPhone in the Giants dugout during the World Series.

So many friends and colleagues have supported me during the baseball season as I chased down photographs with my iPhone at big league ballparks. They include: Tom Adkins, Ray Bathke (@rain man57), Robert Beck (@shoot820), Jon Becker (@jonbecker28), David Benzer (@litbenny), Robert Caplin (@robertcaplin), Jeff Chiu (@jchiu34), Scott Clarke, David Cooper, Chris Covatta (@covatta), Kelley L. Cox (@kelleylcox), Aric Crabb (@crab bsurf), Paul Cunningham (@leatherheadsports), Mahmoud Elkotb (@mahmoudelkotb), Andrew Fingerman (@awfinger), Jean Fruth, Jack Gruber (@guygruber), Nick Harrison (@nativemuscle), Jim Heiser (@jimheiser), Thearon Henderson, Walter Iooss (@walteriooss), Martha Jenkins (@marthajanejenkins), Bruce Kennedy, Kohjiro Kinno (@kohjirokinno), Tim Mantoani, Max

Morse (@maxmorse), Brian Murphy, Candace Murphy, Rusty Phillips (@rustycam), Rich Pilling, Kirk Reynolds (@kirkgaucho), Teri Reynolds (@terireynolds), Eric Risberg, Marcio Sanchez (@marciojsanchez), Jakob Schiller (@jakobschiller), Robert Seale, Ezra Shaw (@eoshaw), Ron Vesely, and Russell Yip (@fyeye).

Finally, I need to thank my very special supporters for all they have done for me. Joe Gosen (@joegosen), Paula Mangin (@paulaballah), Jim Merithew (@tinyblackbox), Allen Murabayashi (@allen3), Grover Sanschagrin (@heygrover), and Justin Sullivan (@sullyfoto), I cannot thank you enough for all of your support.

CAMERON + CO
Publisher: *Chris Gruener*
Art Direction & Design: *Iain R. Morris*
Design Assistant: *Amy Wheless*
Editor: *Mark Burstein*

(707) 769-1617
www.cameronbooks.com

Cameron + Company would like to thank Brad Mangin
for entrusting us with his incredible baseball Instagrams,
Pedro Gomez for his thoughtful and engrossing foreword,
Mark Burstein for his keen editorial eye, Michelle Dotter for
her copy editing skills, Iain Morris for knocking this book's
design out of the park yet again, Amy Rennert for bringing
us this very fun and innovative project, Instagram for their
free app that is revolutionizing the photography world, and
all of the Major League Baseball players, coaches, and fans
who make this book (and baseball in general) what it is.

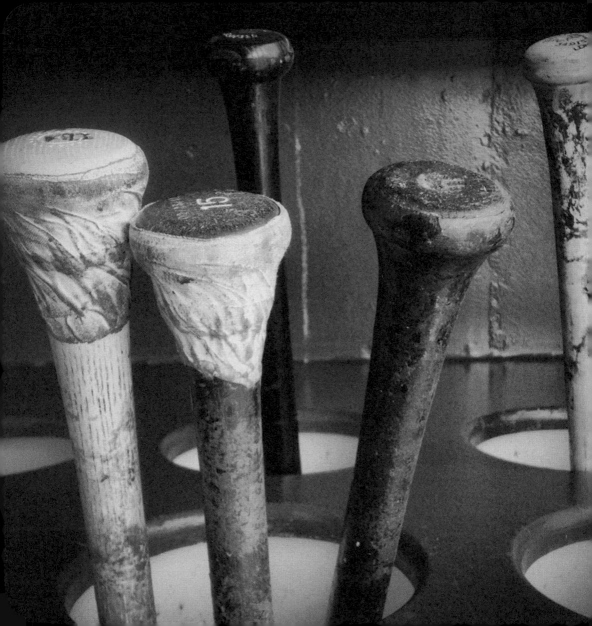